iNSPiReD COLORiNG
OCEAN

This edition published by Parragon Books Ltd in 2016

Parragon Inc.
440 Park Avenue South, 13th Floor
New York, NY 10016
www.parragon.com

Copyright © Parragon Books Ltd 2016

All images courtesy of Shutterstock

Introduction by Dominic Utton

ISBN 978-1-4748-4121-4

Printed in US

INSPIRED COLORING

OCEAN

COLORING TO RELAX AND FREE YOUR MIND

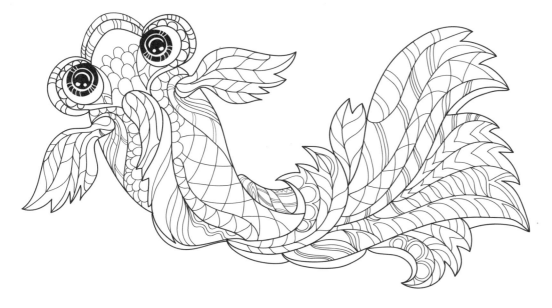

PaRragon

Bath • New York • Cologne • Melbourne • Delhi
Hong Kong • Shenzhen • Singapore

Life moves at a fast pace. Sometimes it can seem like a race against time just to keep up with everything that needs doing each day, and when we do have time out, we often don't spend it wisely on calming, creative activities.

It's incredibly important that we take time for ourselves on a regular basis. The most beneficial way to do this is to indulge in something that stimulates our right brain (the side that deals with creativity, intuition, and visualization) and brings us to a more mindful state. The simple pleasure of a coloring book checks all the right boxes, with the added bonus of producing something beautiful in the process.

There's no special skill or equipment required; just choose a page you feel drawn to, pick up a pencil, and begin bringing the image to life. The concentration that is required will quickly empty your mind, de-stress you, and help you feel more grounded. However, it's not all about finding a kind of zen—it's also incredibly enjoyable and rewarding. Just as everyone has a novel in them, we all have an inner artist waiting to be set free. If art isn't already a part of your life, you'll be surprised at just how easy it is to create something you're proud of, and how naturally the creativity flows. Your skill will improve the more you color and as you get used to using different tools and techniques.

Inside these pages, you will be transported under the sea by the striking selection of illustrations—including colorful fish, elegant seahorses, and beautifully intricate shells—all waiting for your personalized creative touch. Choose which element of the design you want to stand out, what colors you want the creatures to be, and even add small designs of your own along the way. The black and white images give you the freedom to create and fully explore your artistic side.

If the simple act of concentrating on coloring has a meditative, therapeutic effect, then there are also myriad reasons why flexing our creative muscles can only be a good thing. There are countless psychological studies that show the benefits of creativity—from reducing stress to decreasing the likelihood of depression, and even improving confidence and a more optimistic outlook.

One thing that steers many people away from making art a part of their life is the time involved. However, the very nature of coloring books means they're perfect for modern life. A watercolor artist might need days in the field with his easel, a sculptor might slave for weeks in the studio over a single creation, but a book like this can be carried around with you as you go about your day, picked up and set down as needed, opened or shut as the mood takes. Any and every spare moment is an opportunity, whether you have five minutes or five hours.

Can you name an activity that's creative, that's good for your mental well-being, that helps relieve stress, reconnects you with your inner artist, improves hand-eye coordination and concentration, and that you can carry around with you and dip into wherever you go? Inspired Coloring is all these things—and with every new creation you work on, the benefits can only increase.

Finally, a word about materials and techniques. One of the best things about coloring is that you don't need to splash out on a whole range of specialized materials or expensive equipment, and different techniques can simply be picked up (or ignored) as you go. There are no rules, and whatever you do can never be definitively declared "wrong."

Of course, however, it can be exciting to have an excuse to splash out on some new goodies, so if you do feel like a trip to your local stationery store or art store, you could do worse than invest in the following:

Pencils of varying grades—HB is the standard; for finer, harder lines or crosshatching consider an H or even 2H, and for thicker lines and smudging for shading, a B, 2B, or 3B.

Colored pencils—a good-quality package of just about every color you could want will be relatively inexpensive.

A pencil sharpener and eraser—for keeping things tidy; a kneadable eraser is best for picking up marks without smudging.

As for techniques, again there are no rules. Some people like to color in blocks in the traditional way, others to use pencils to shade or crosshatch (that is, to make a kind of grid of varying width and/or thickness to imply depth or shade).

Others might make patterns of their own design, or use darker pencils in the outer corners of each section with lighter pencils inside. The point is, do whatever works for you.

These are your designs and there is no right or wrong way of making them beautiful. The process of coloring in is at least as important as the result.

So relax, empty your mind, set free your artistic flair, and enjoy the unique therapeutic effect of Inspired Coloring. And most of all: Have fun!

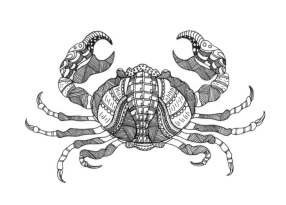

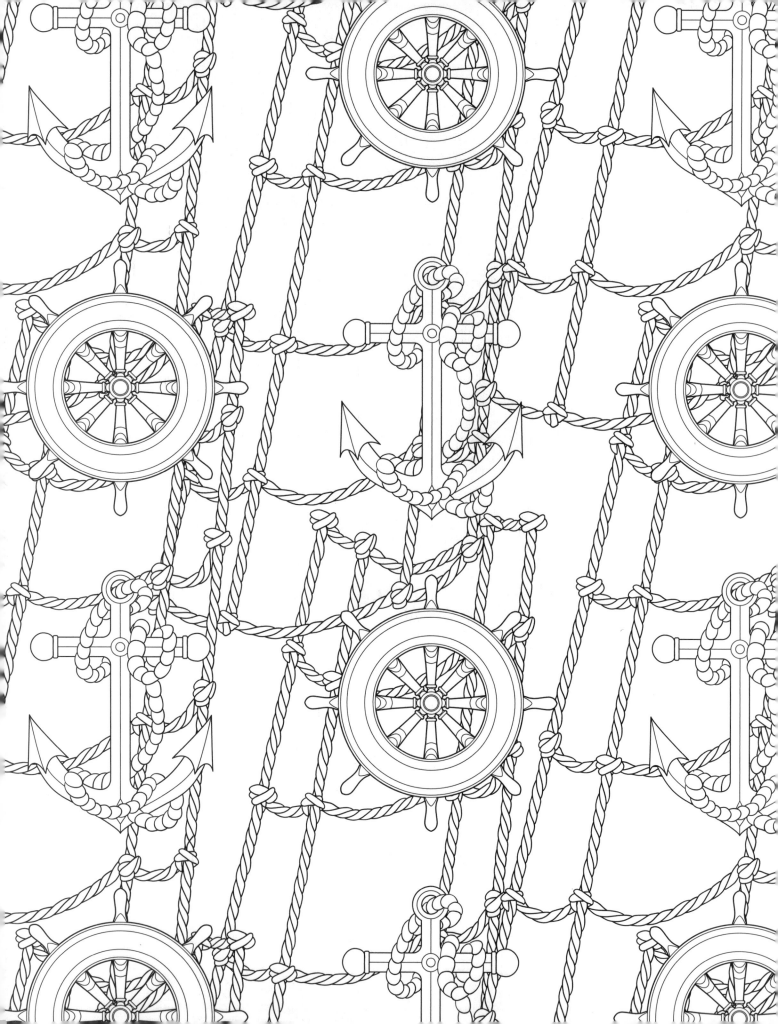

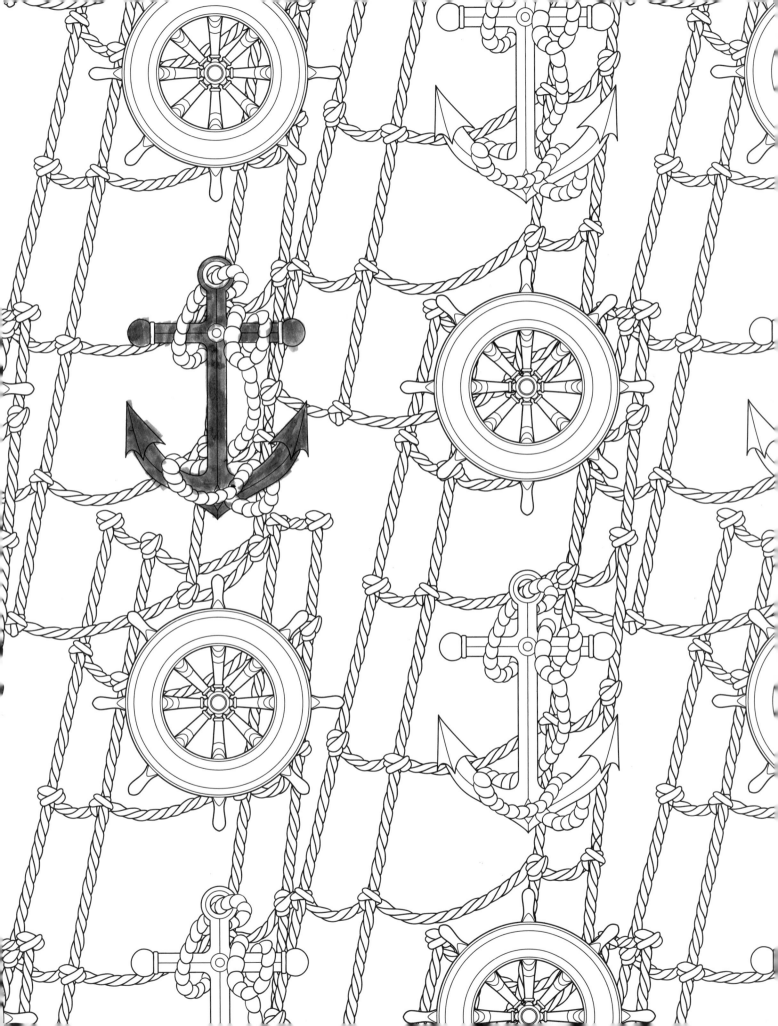

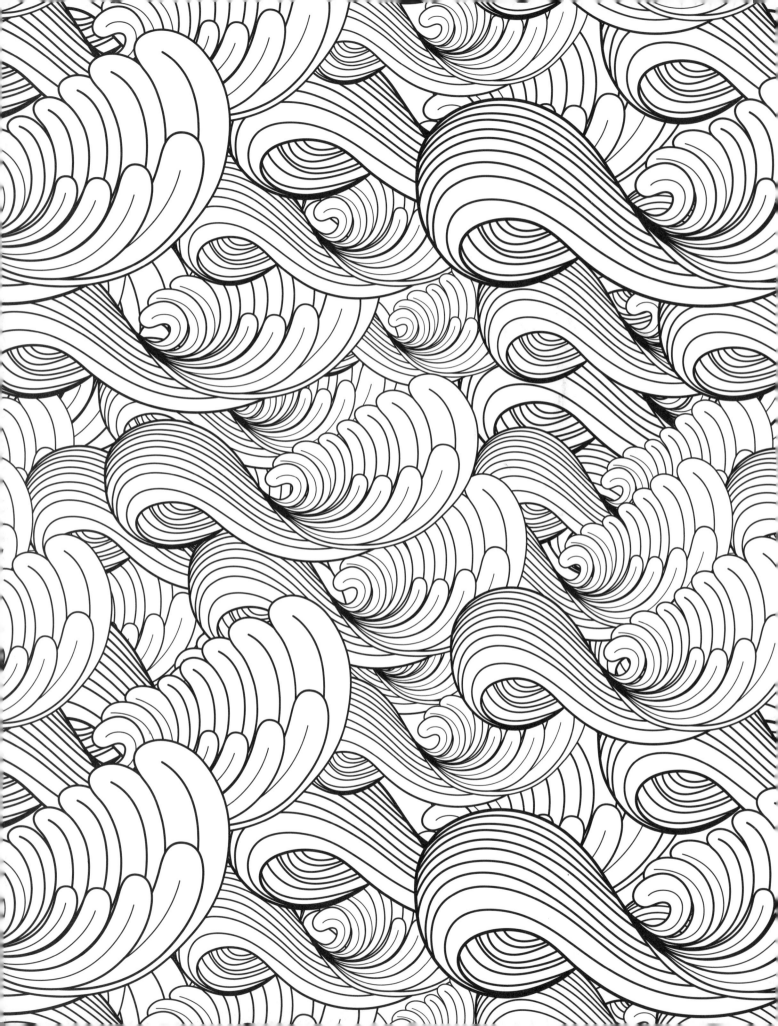

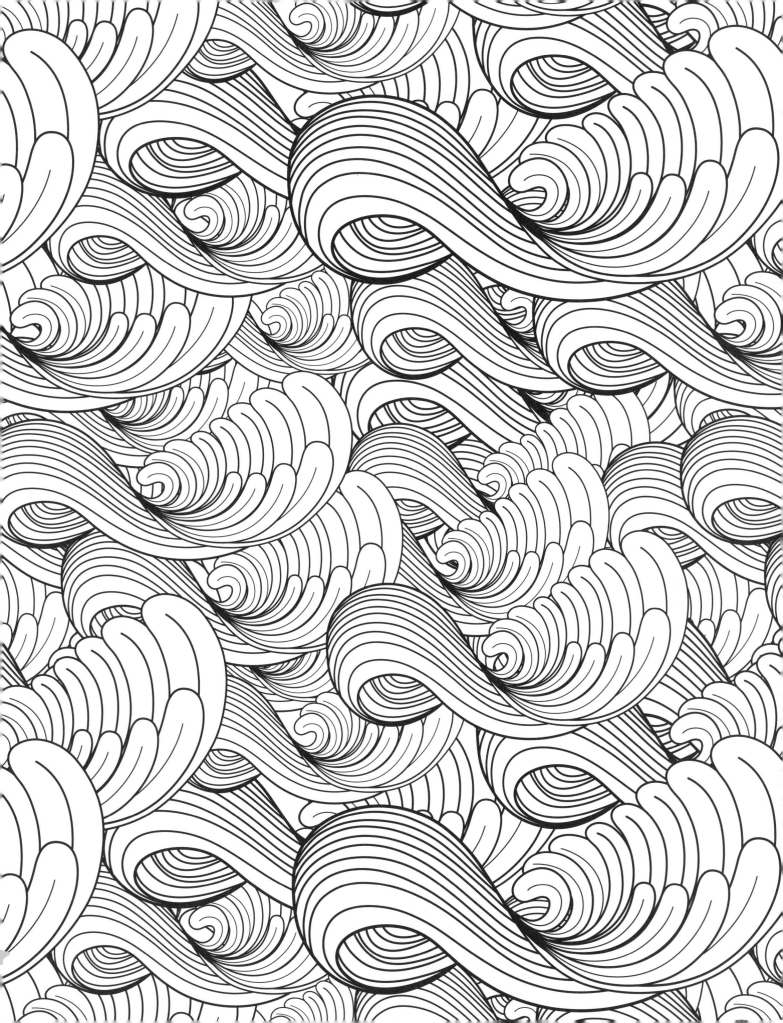

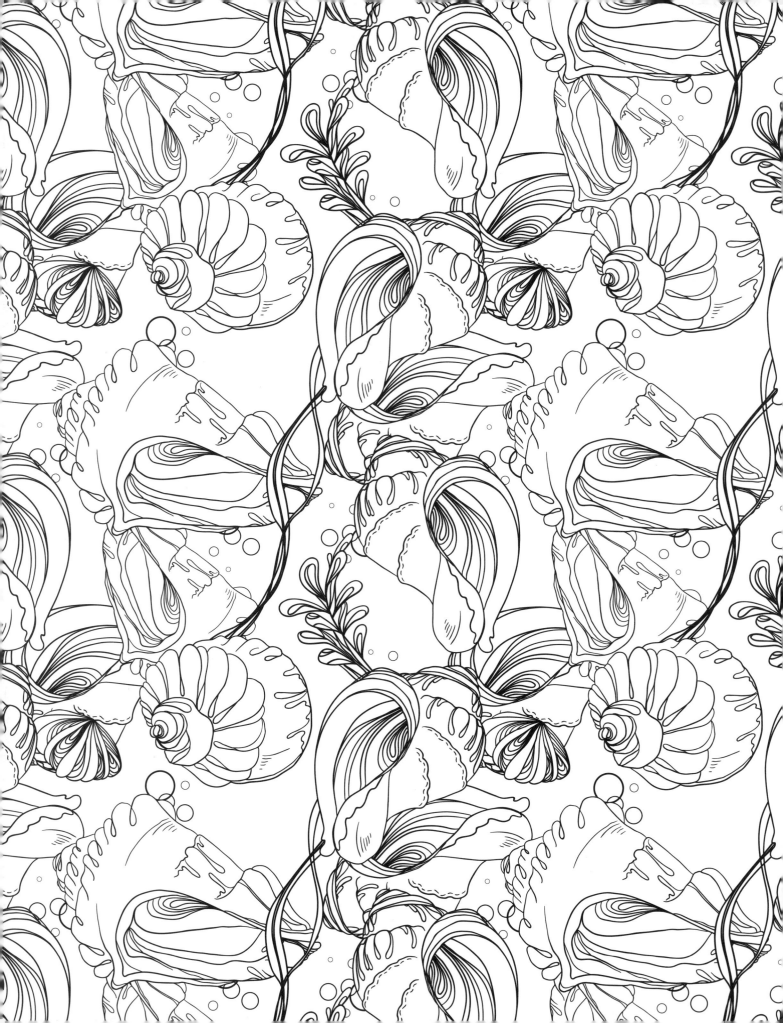

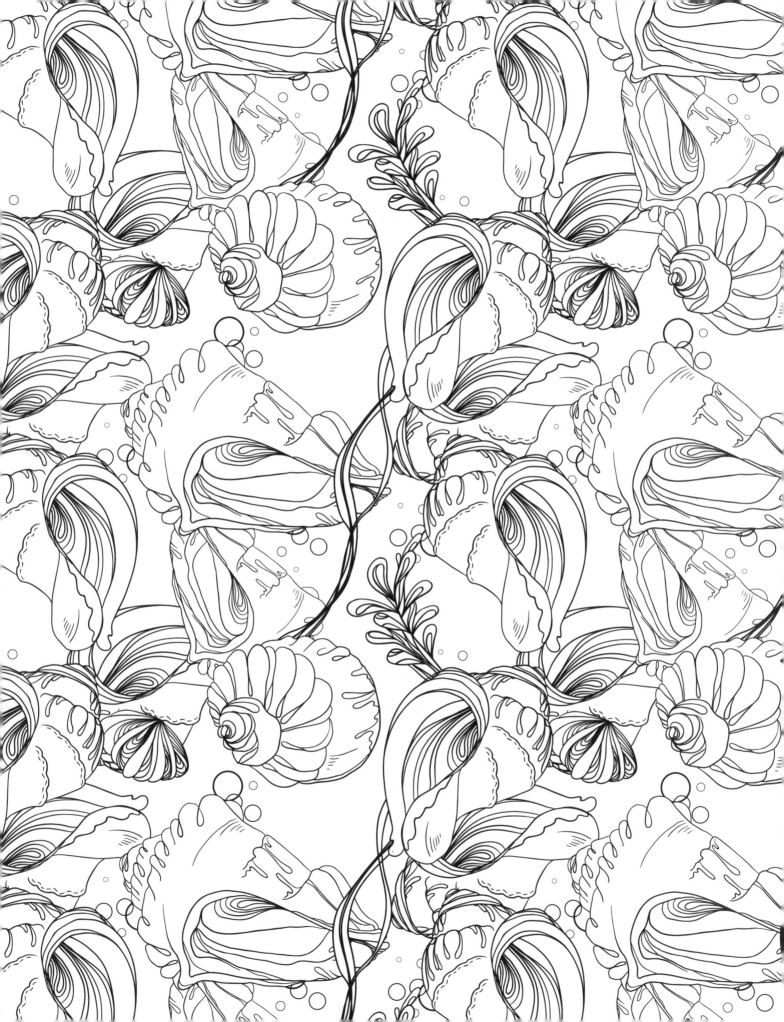

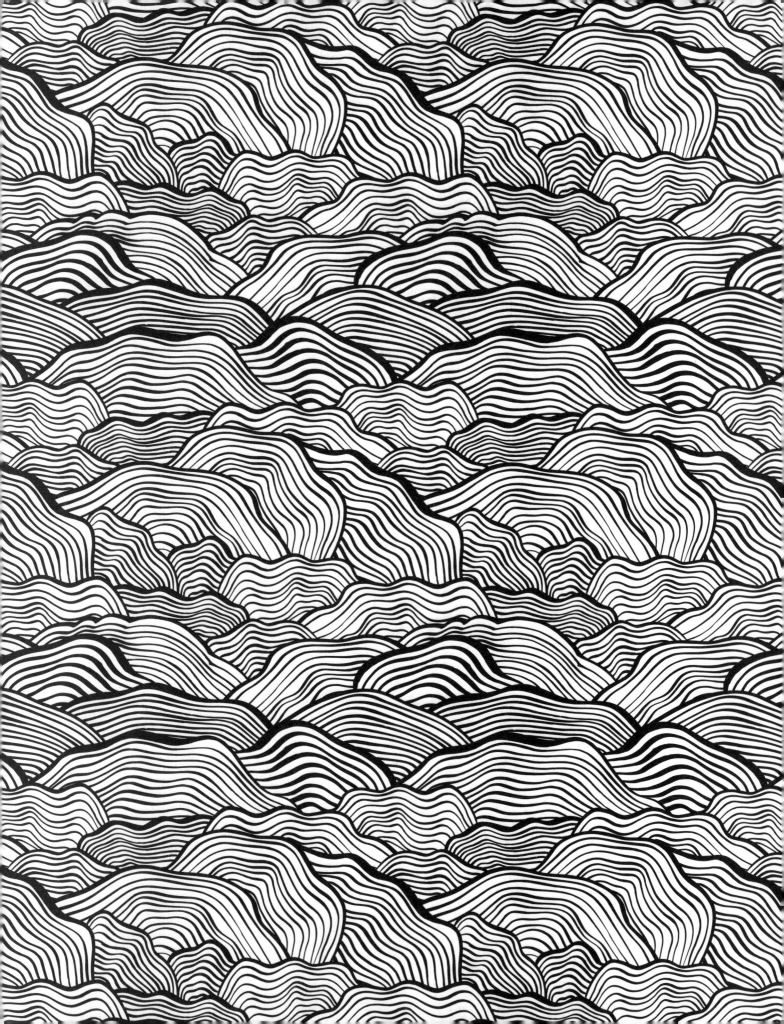

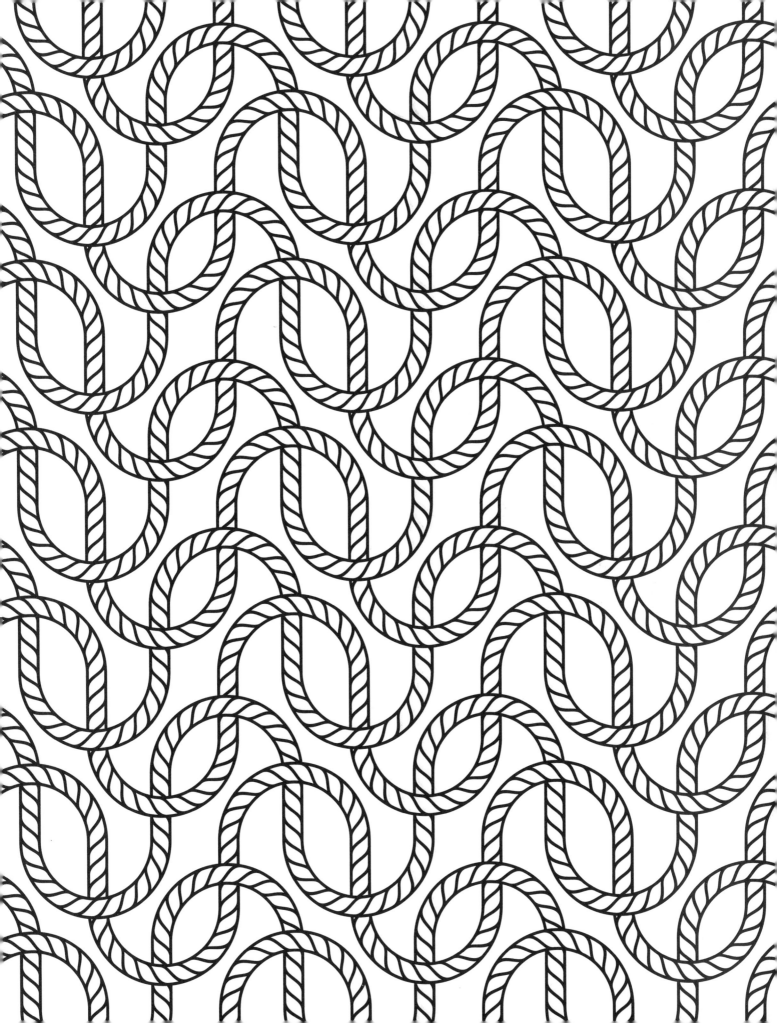

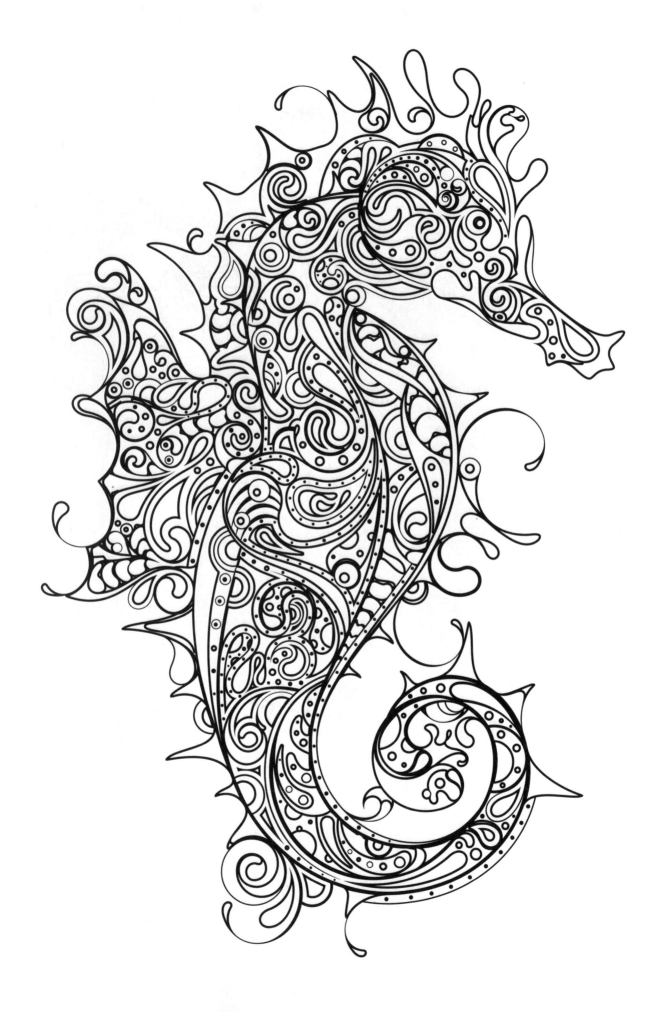

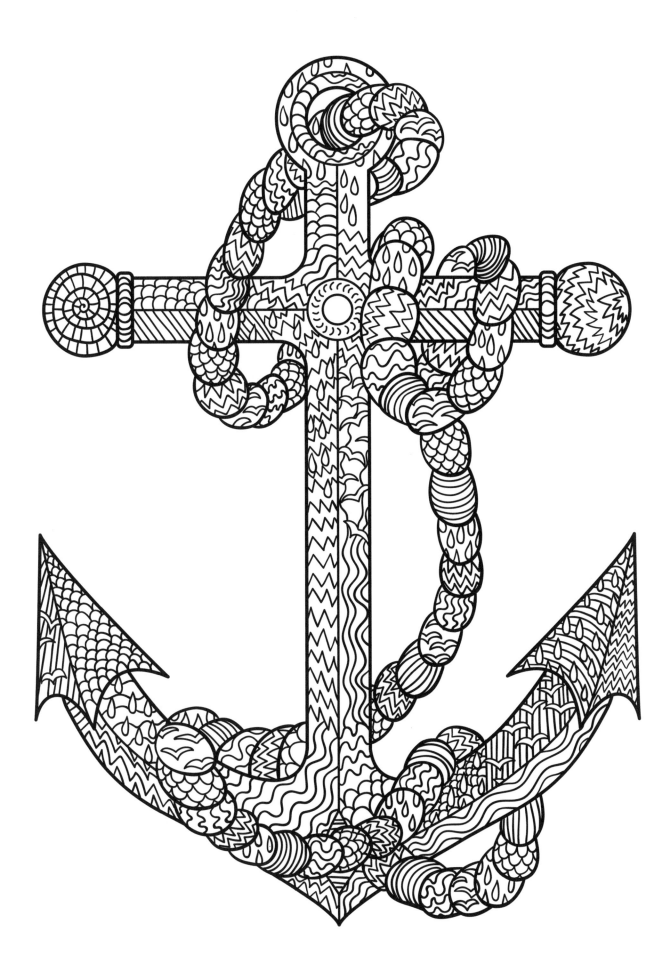

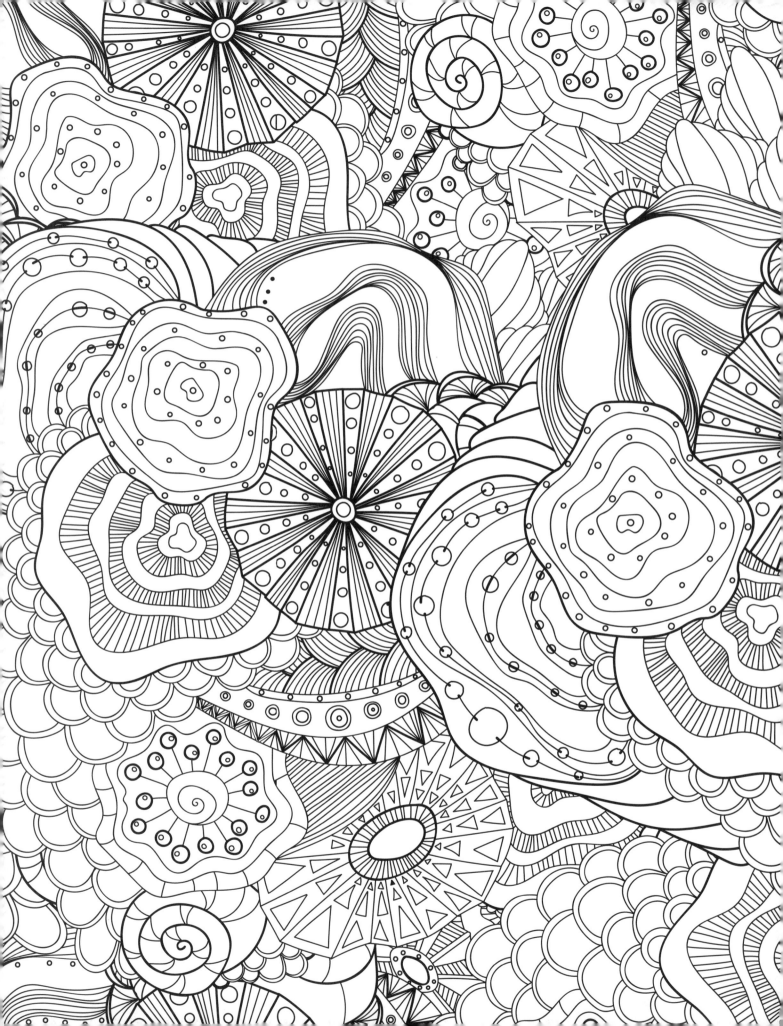

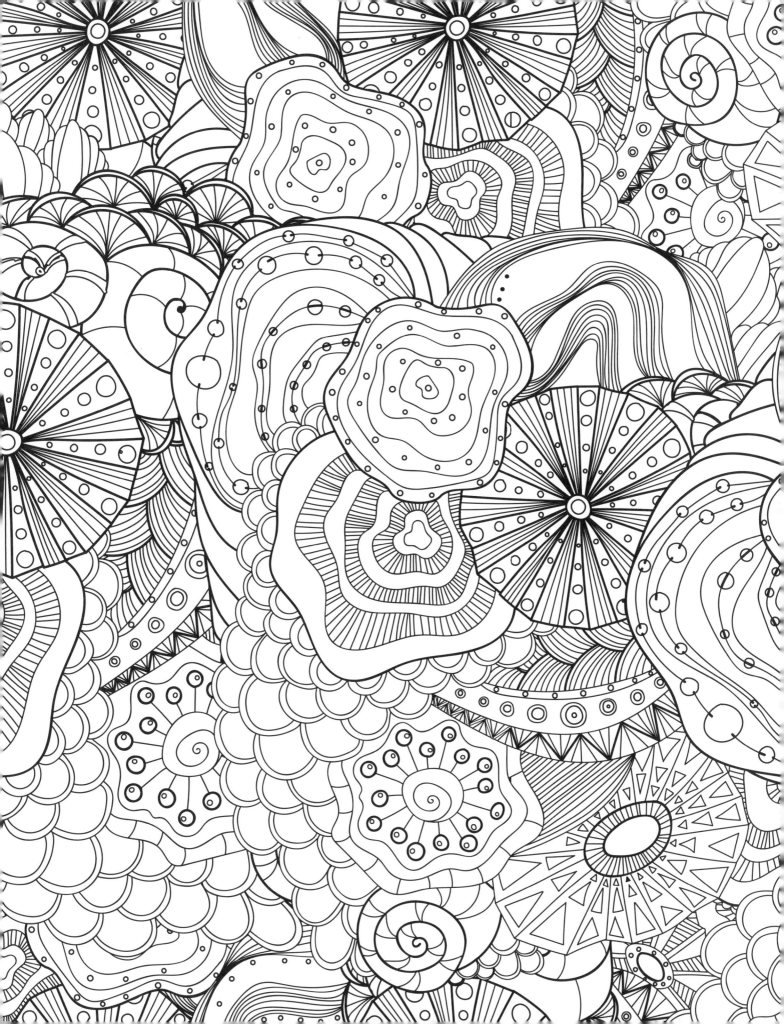

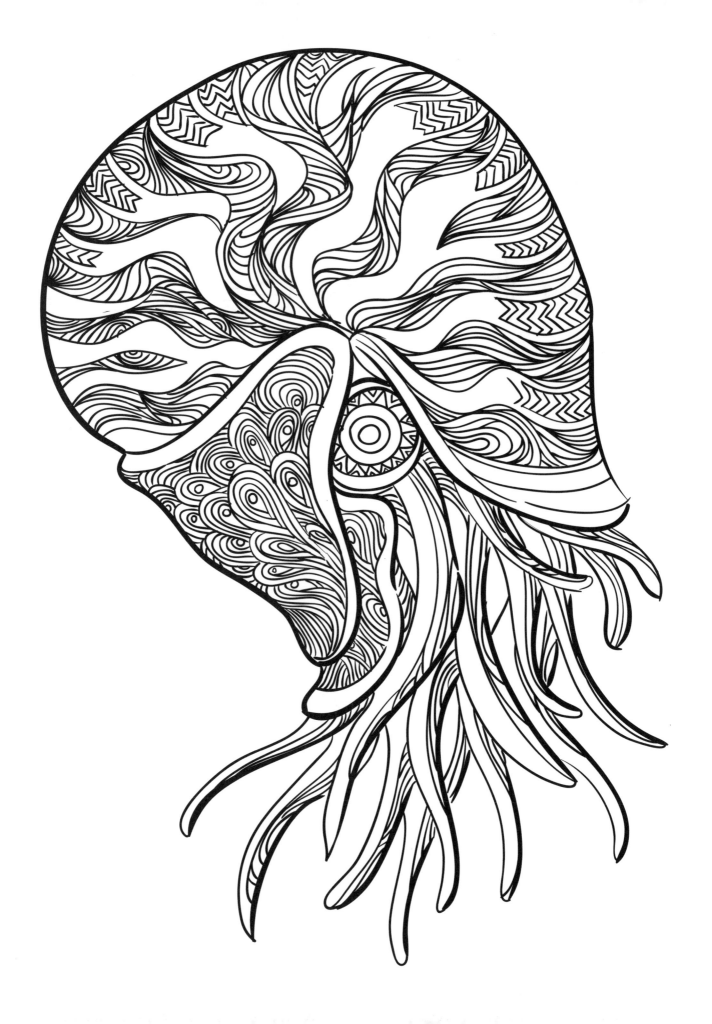

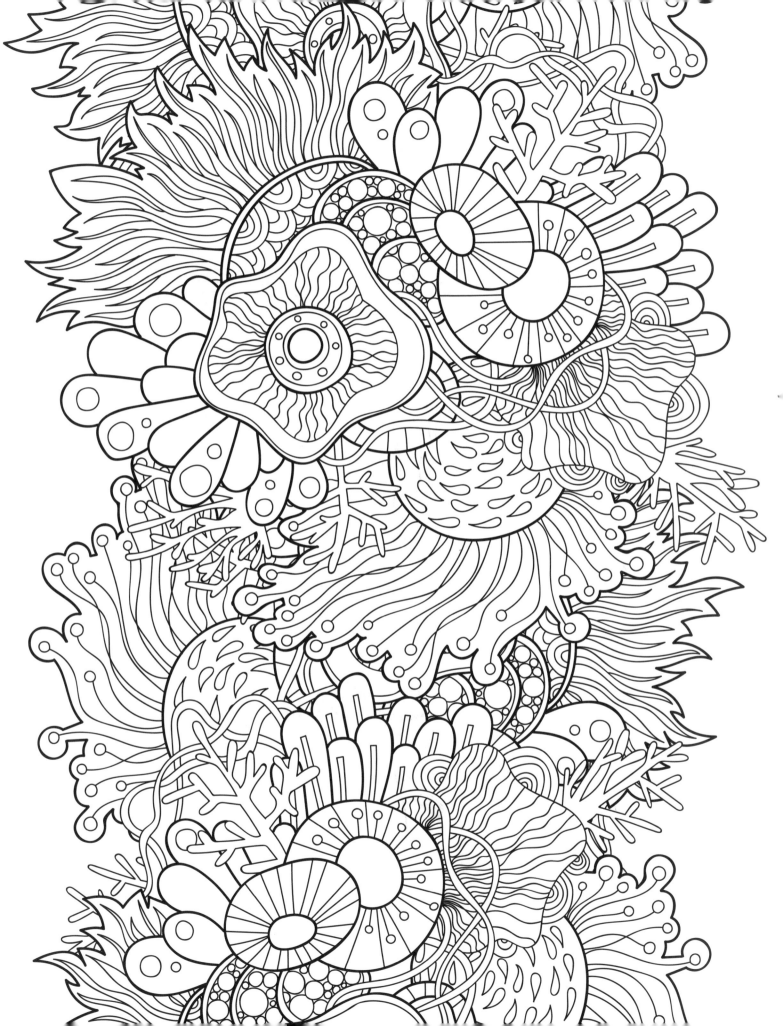

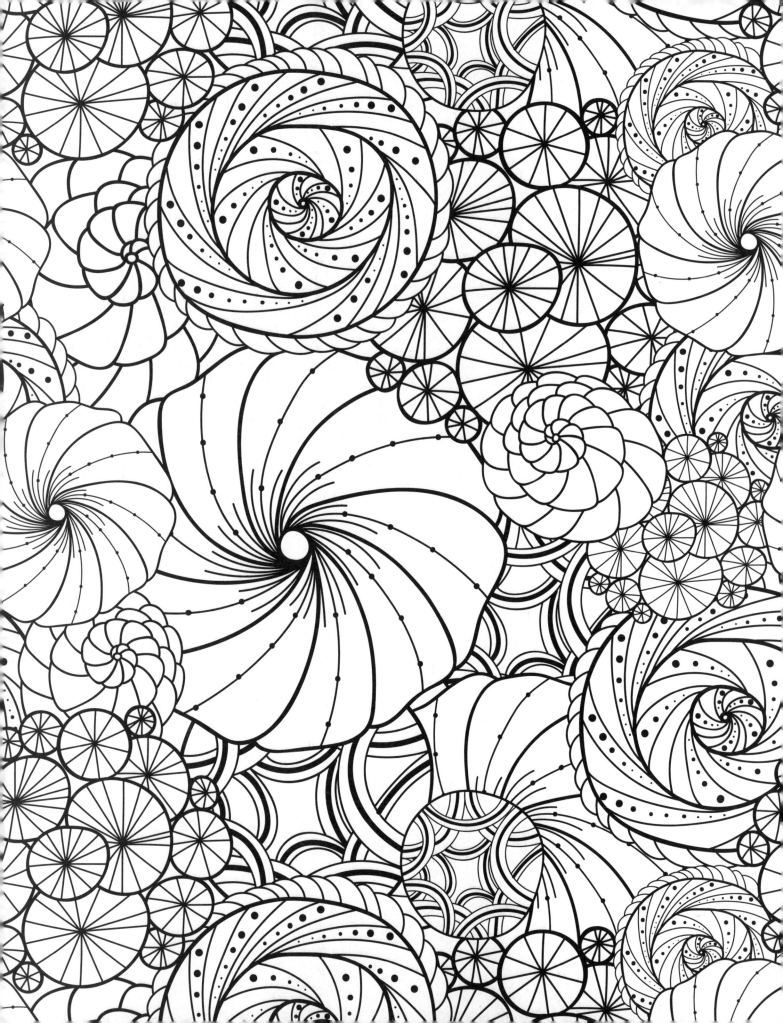

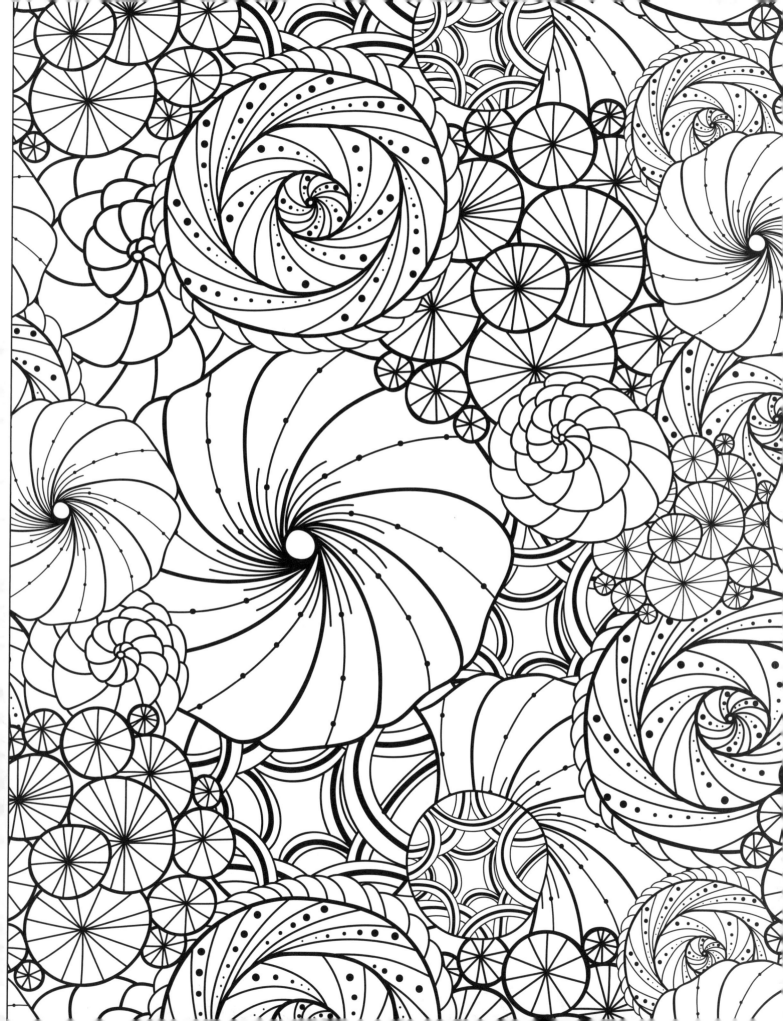

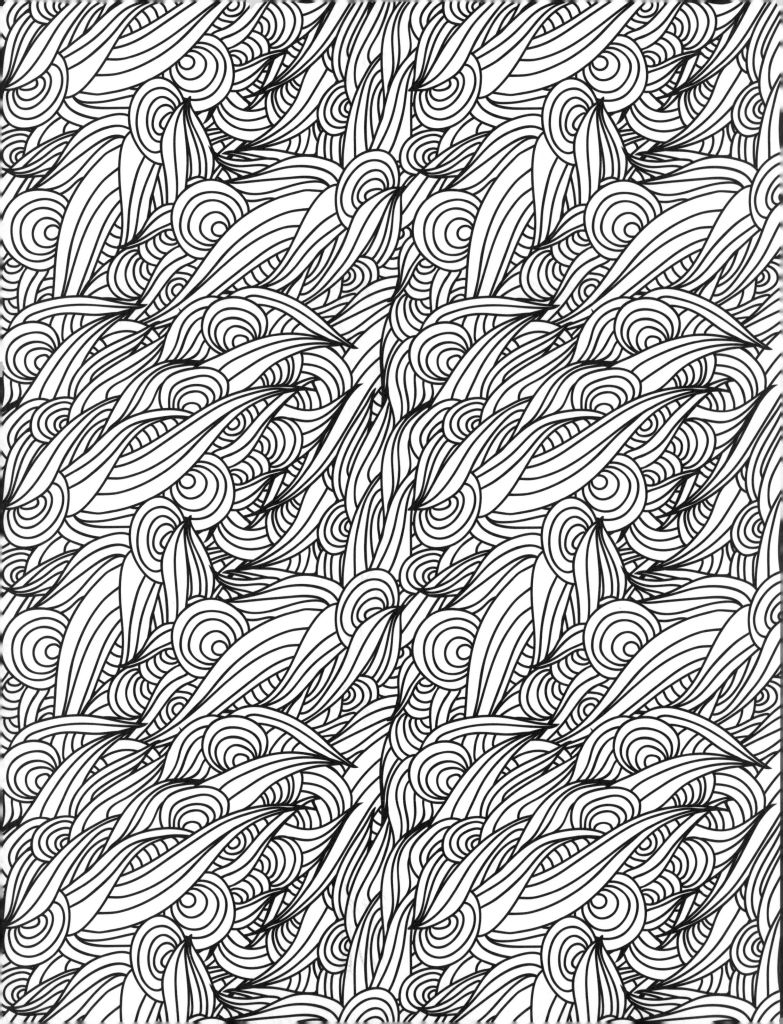

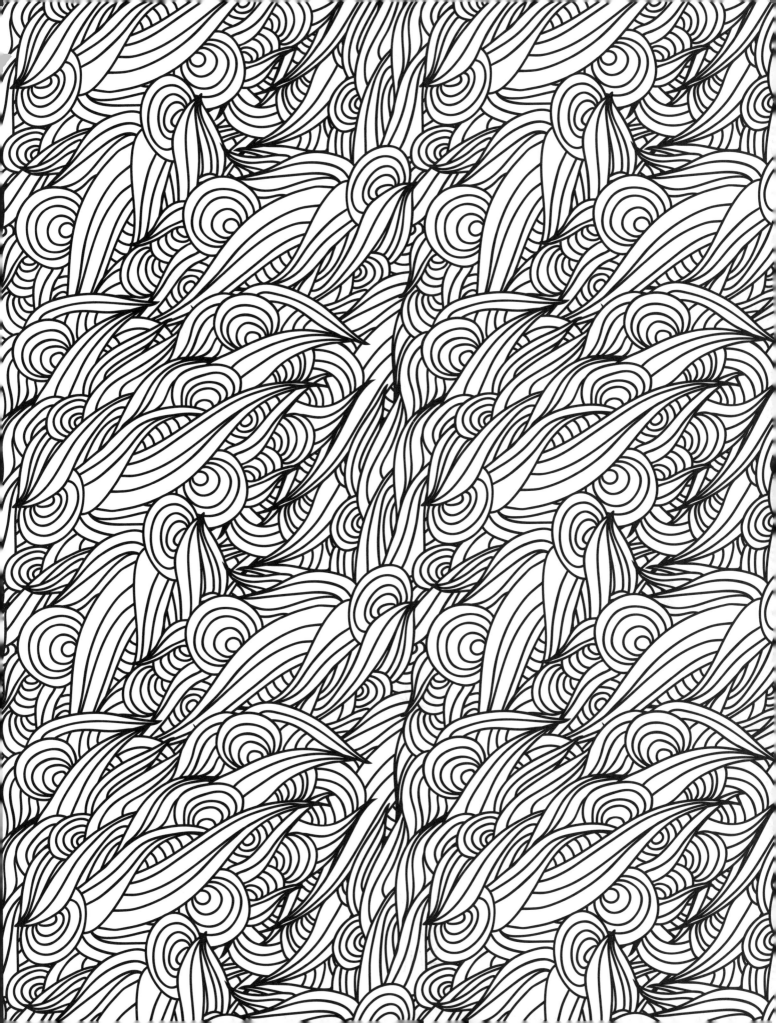

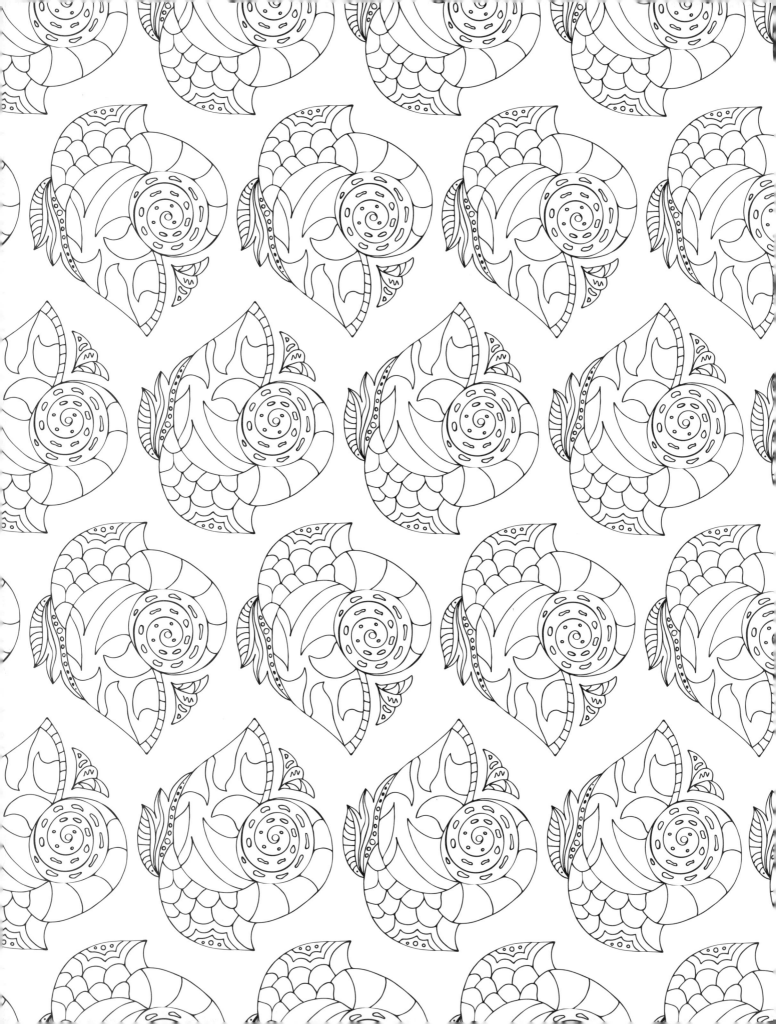

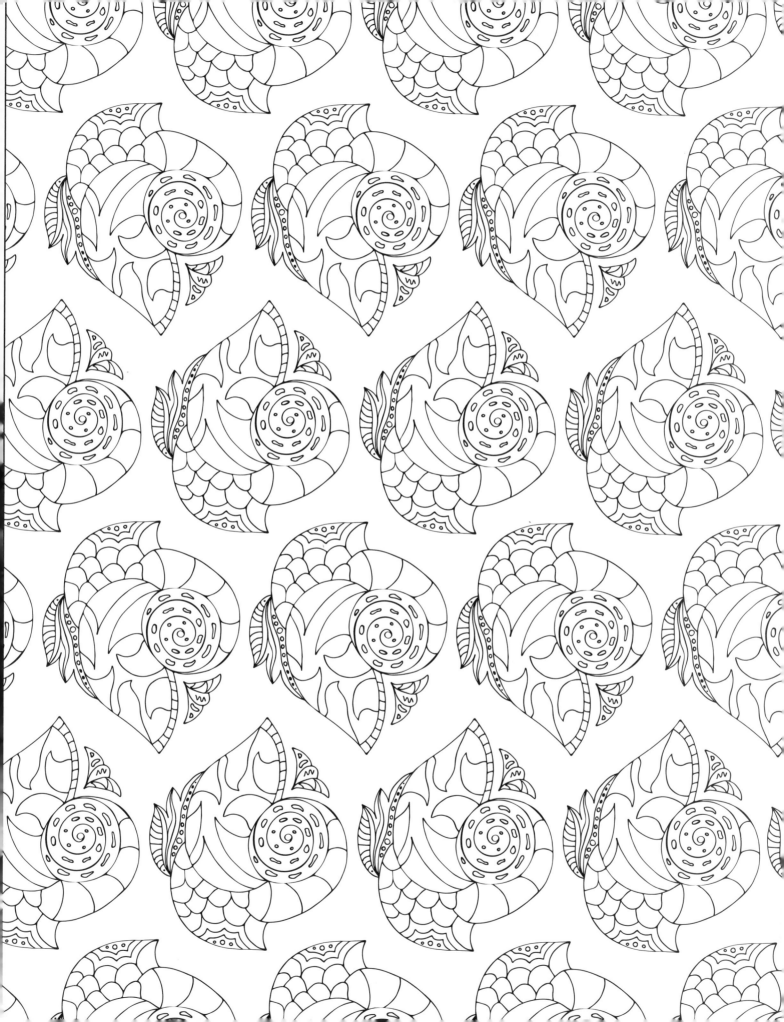

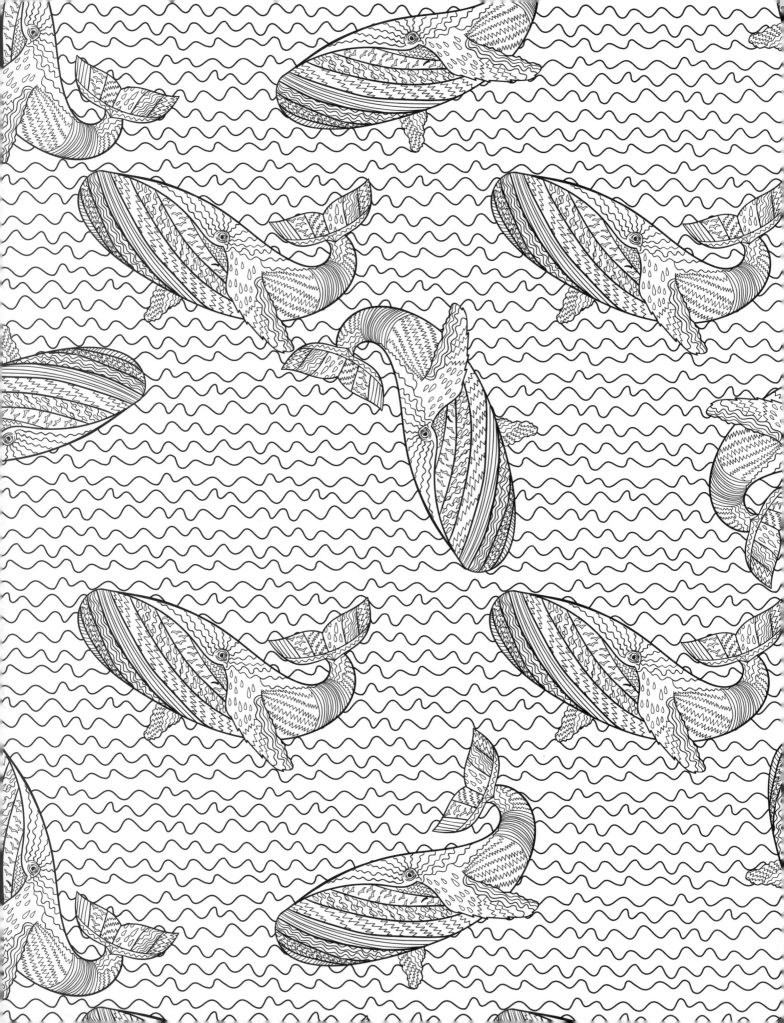

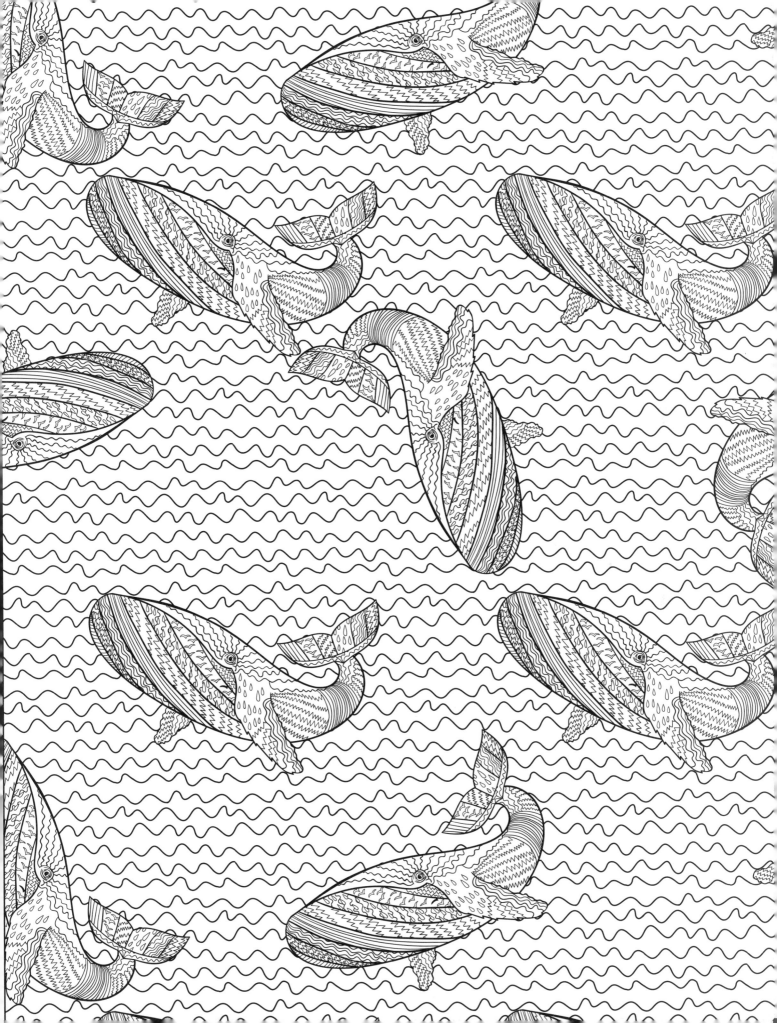

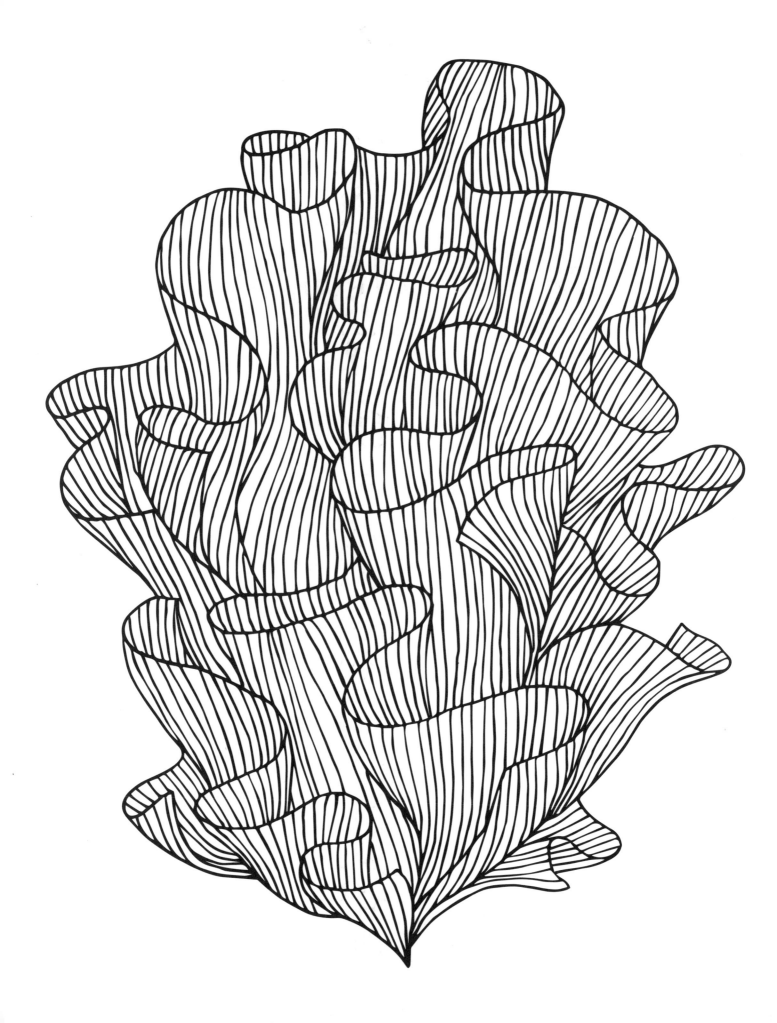

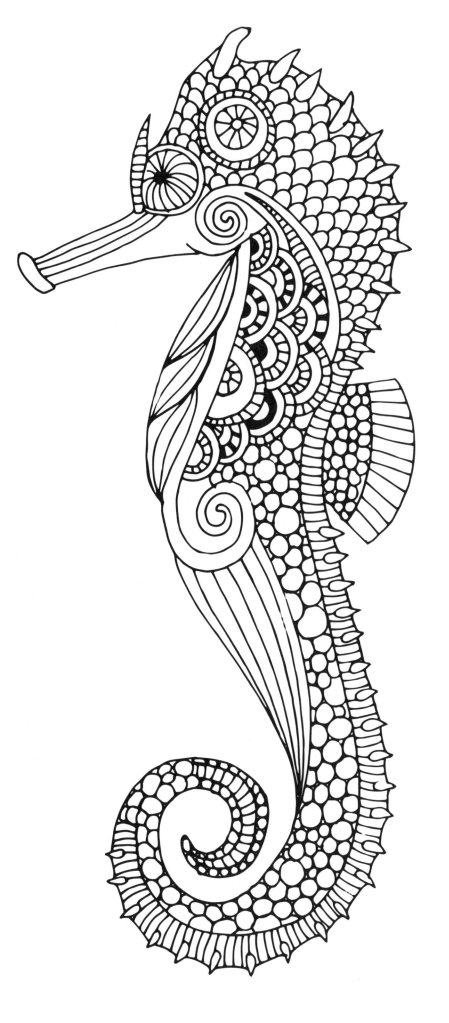

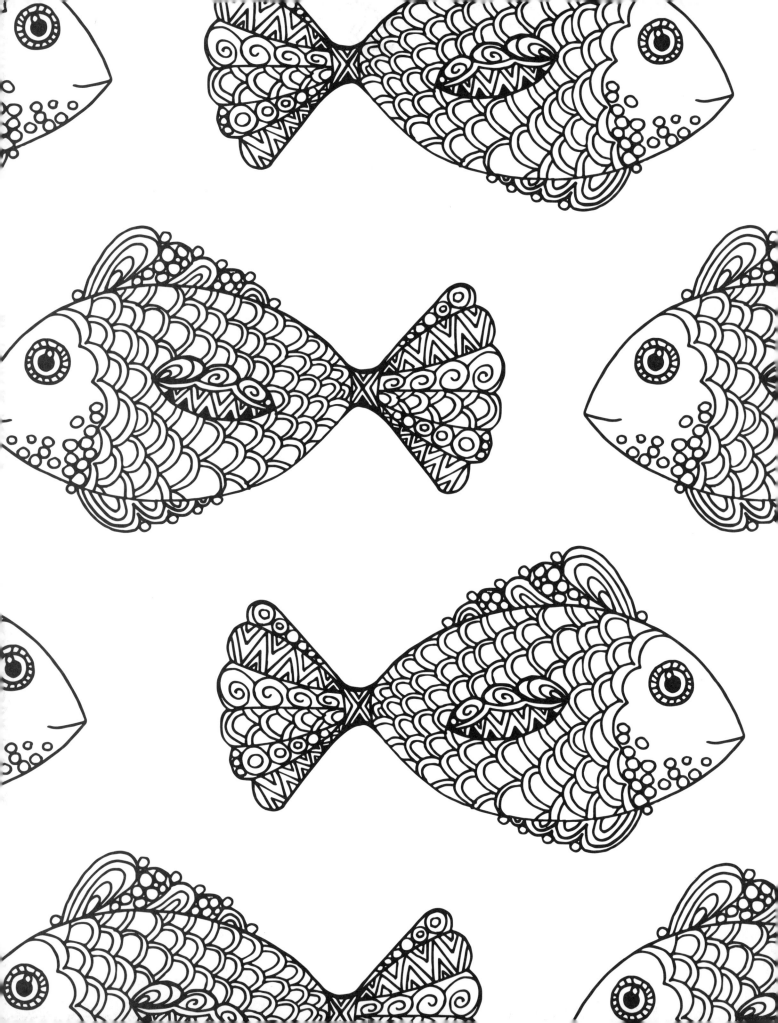

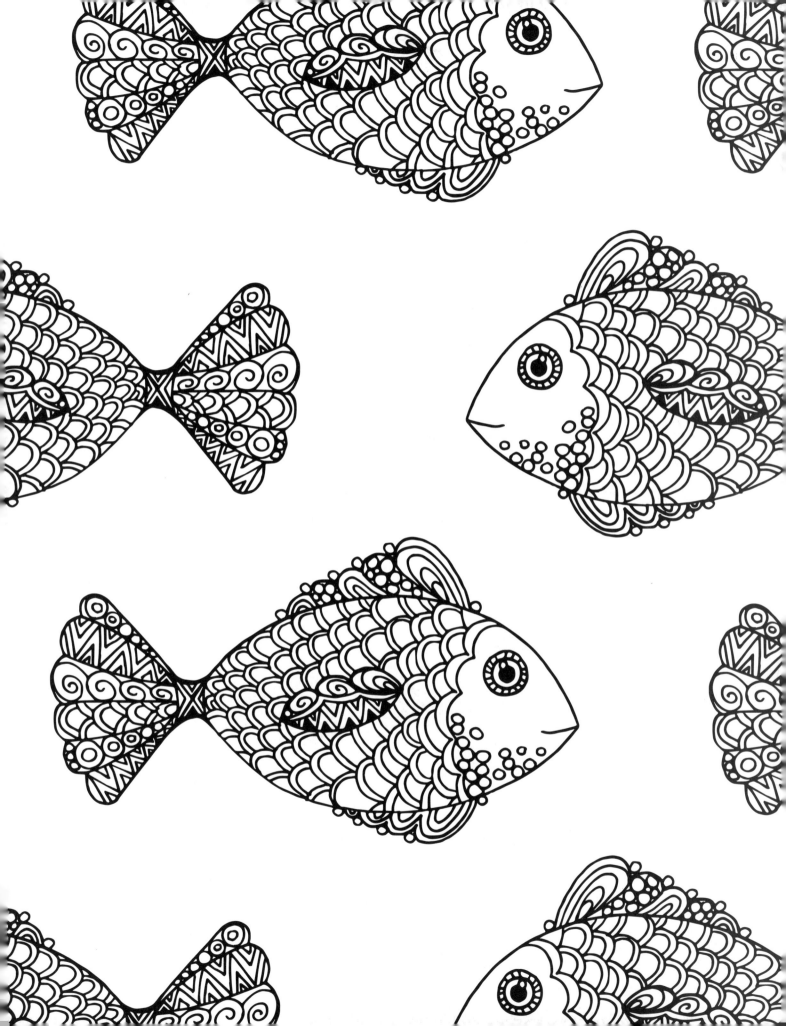

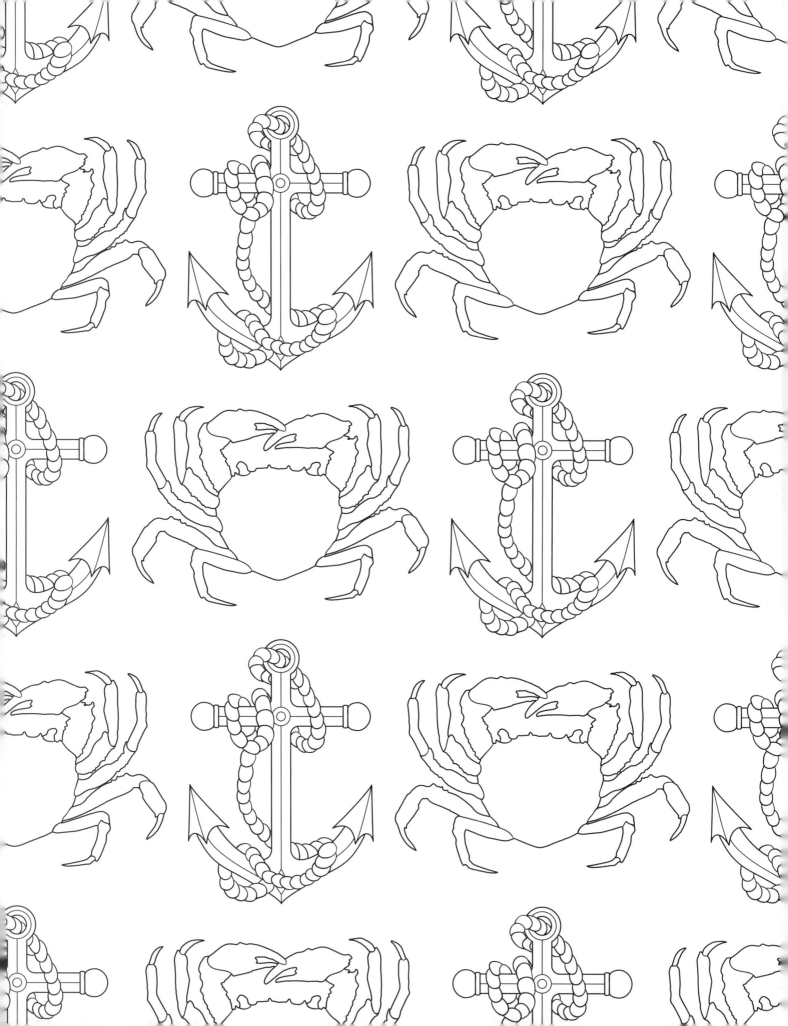

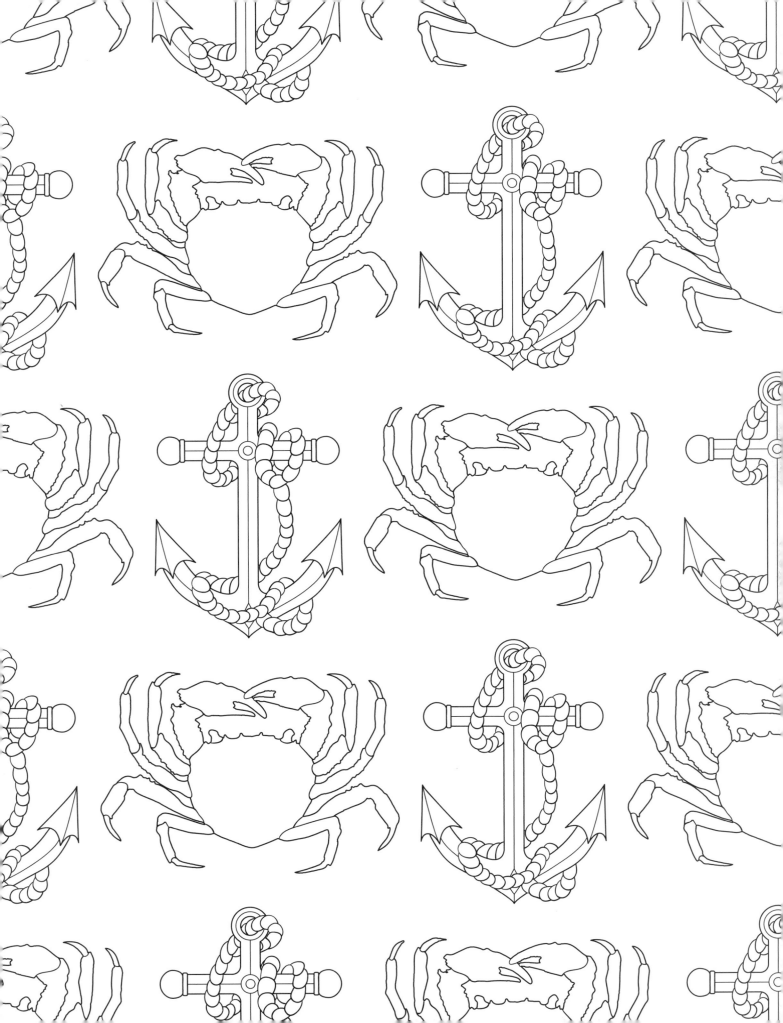

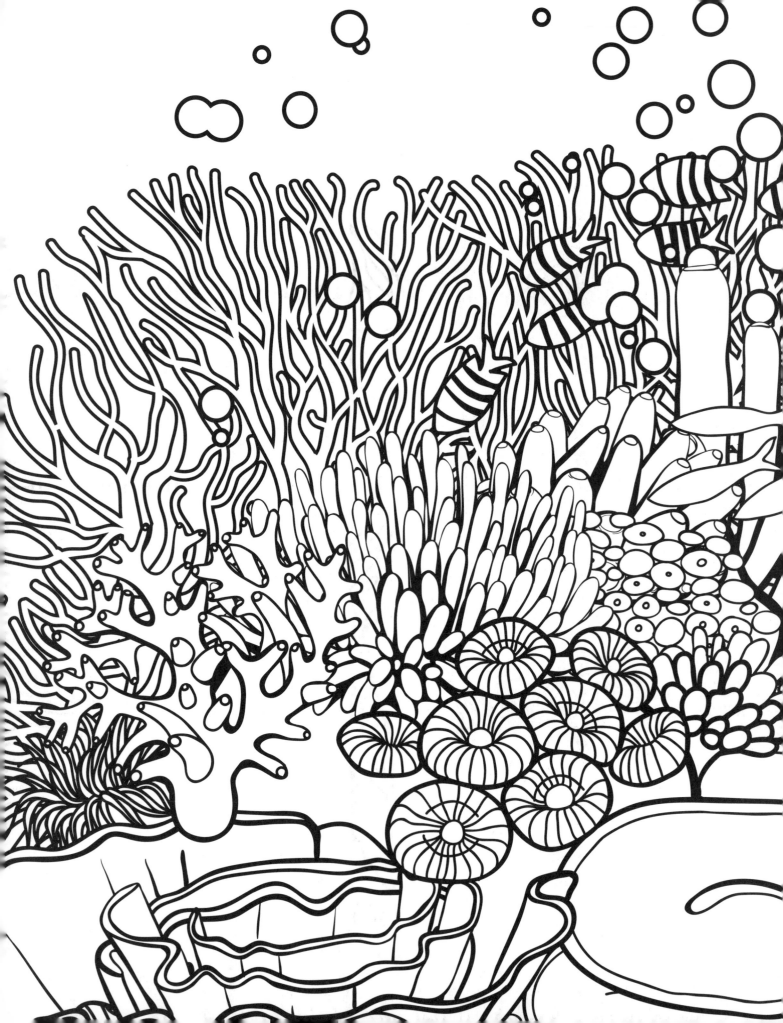

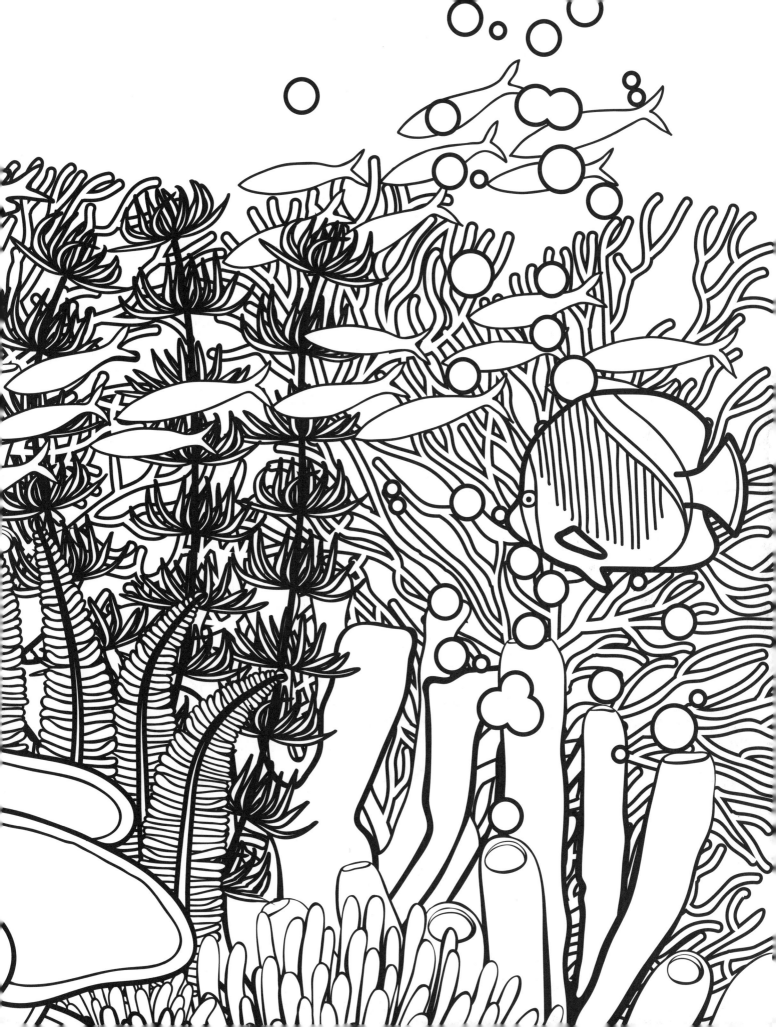

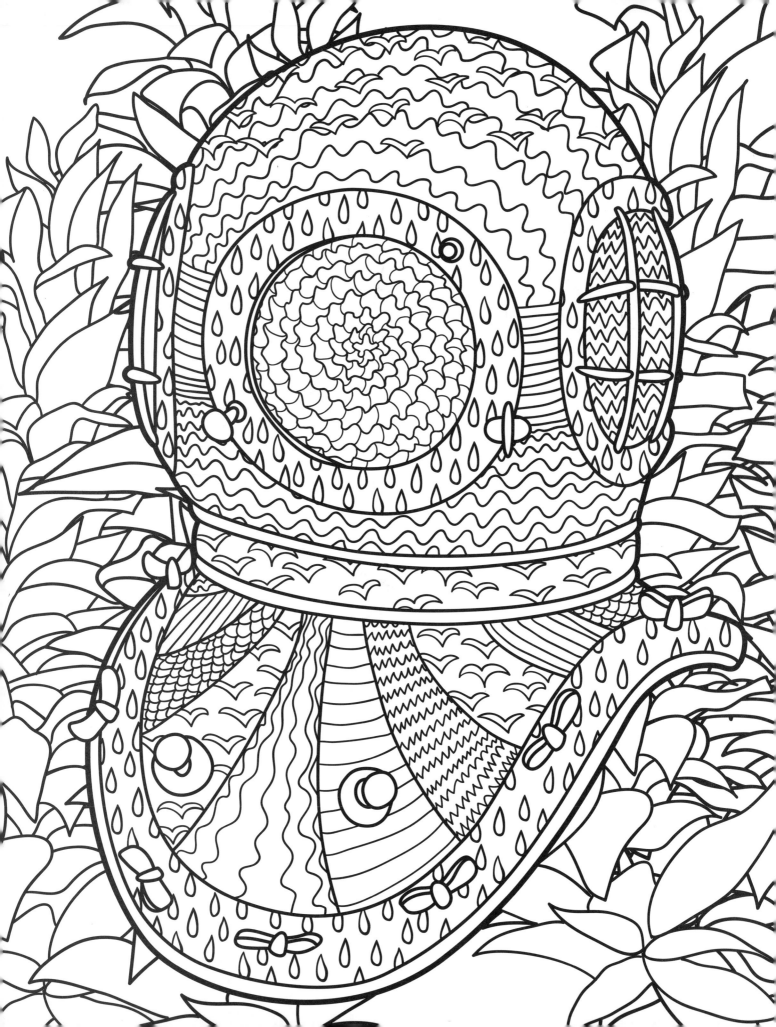

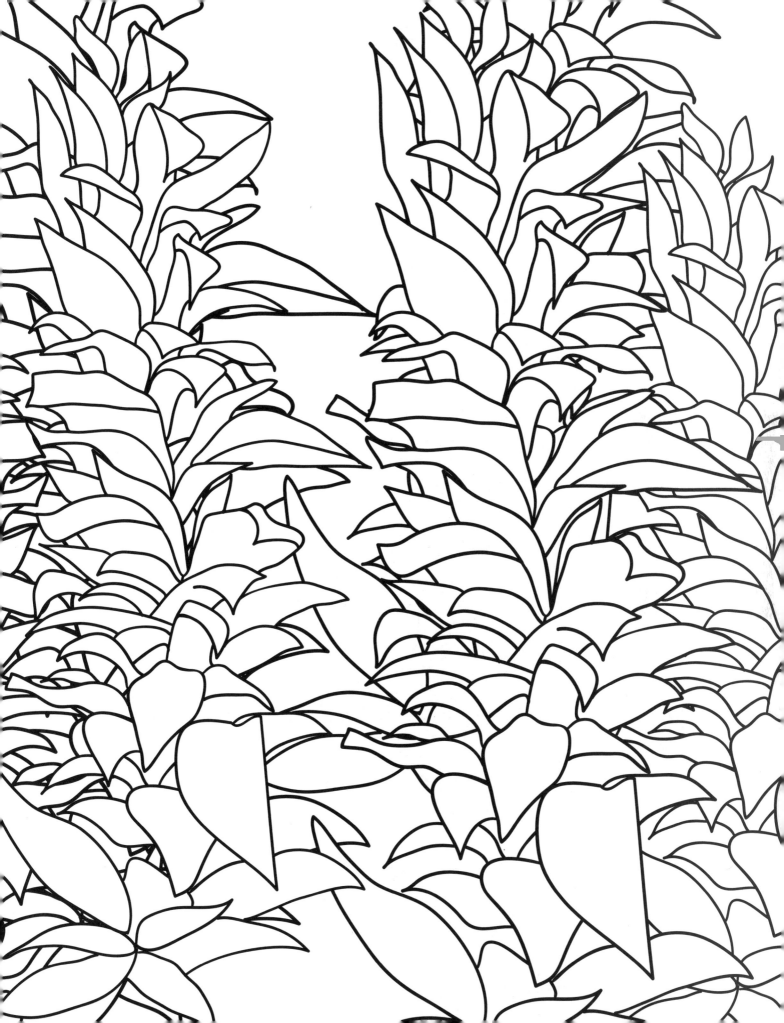

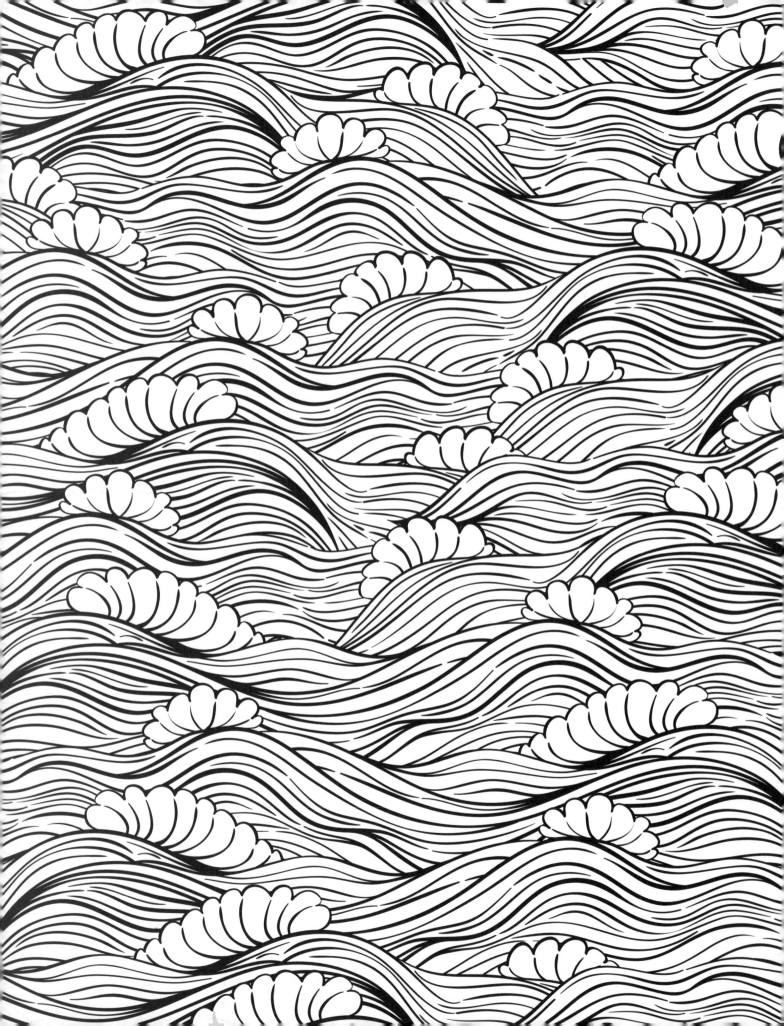

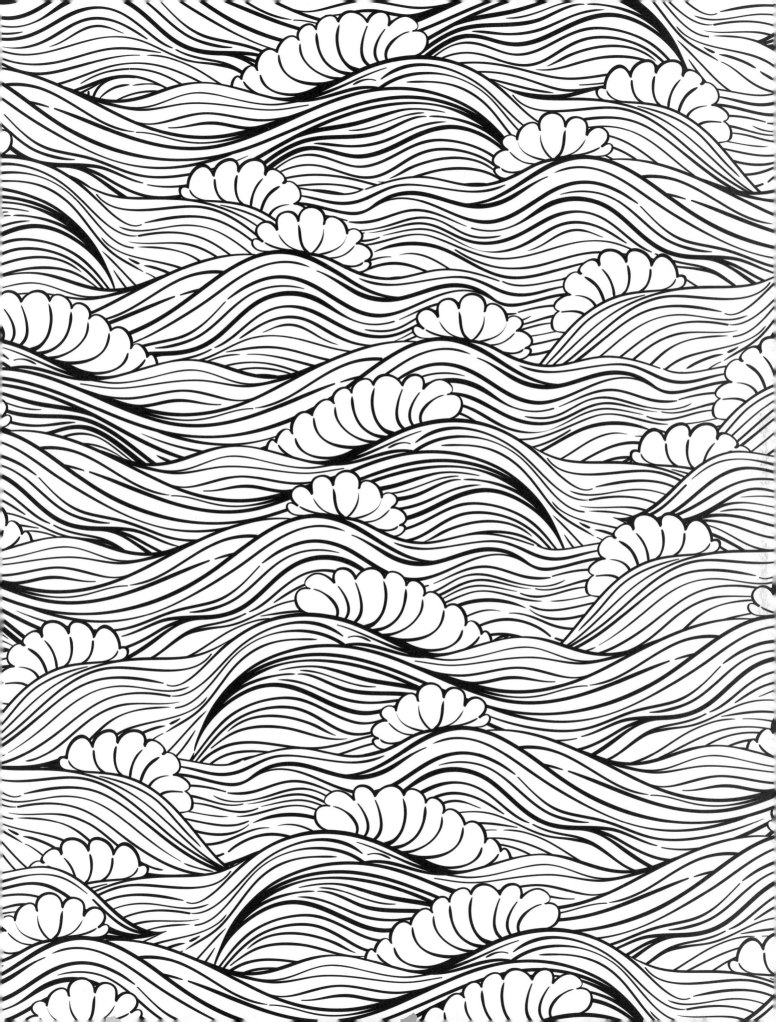

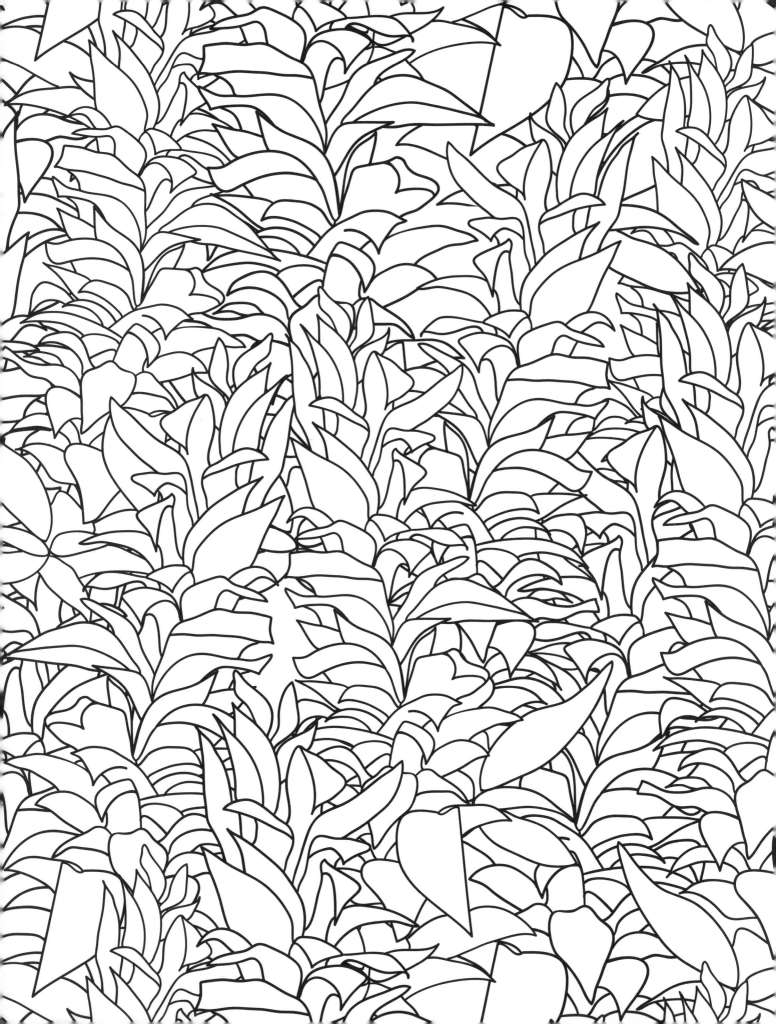

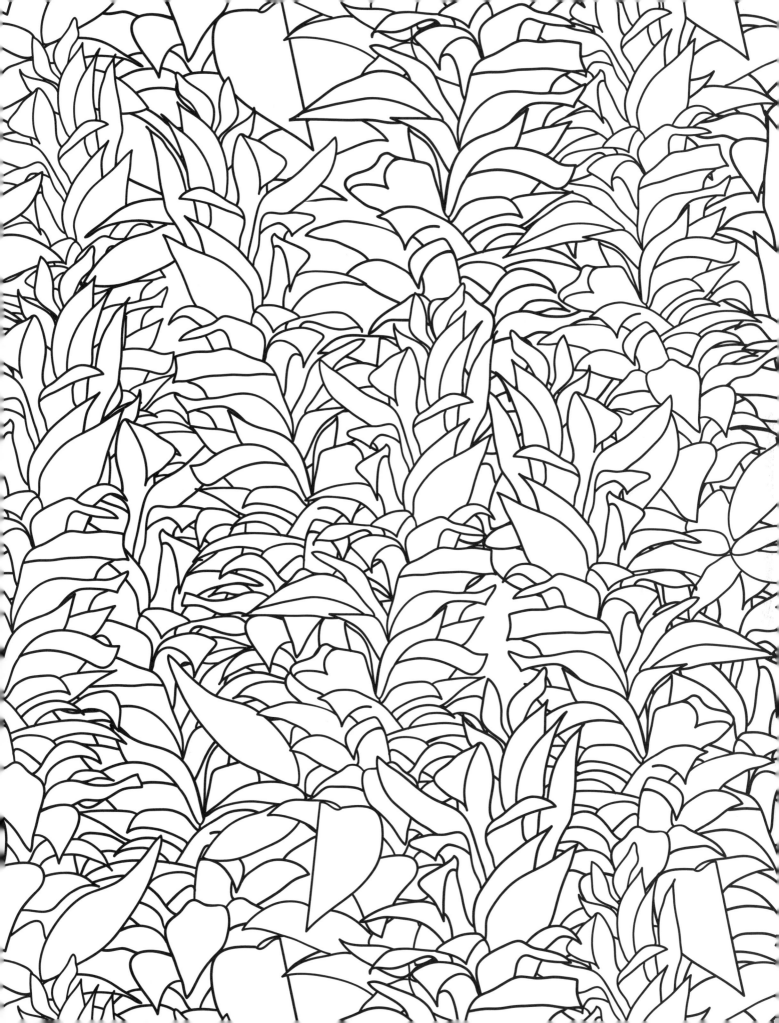

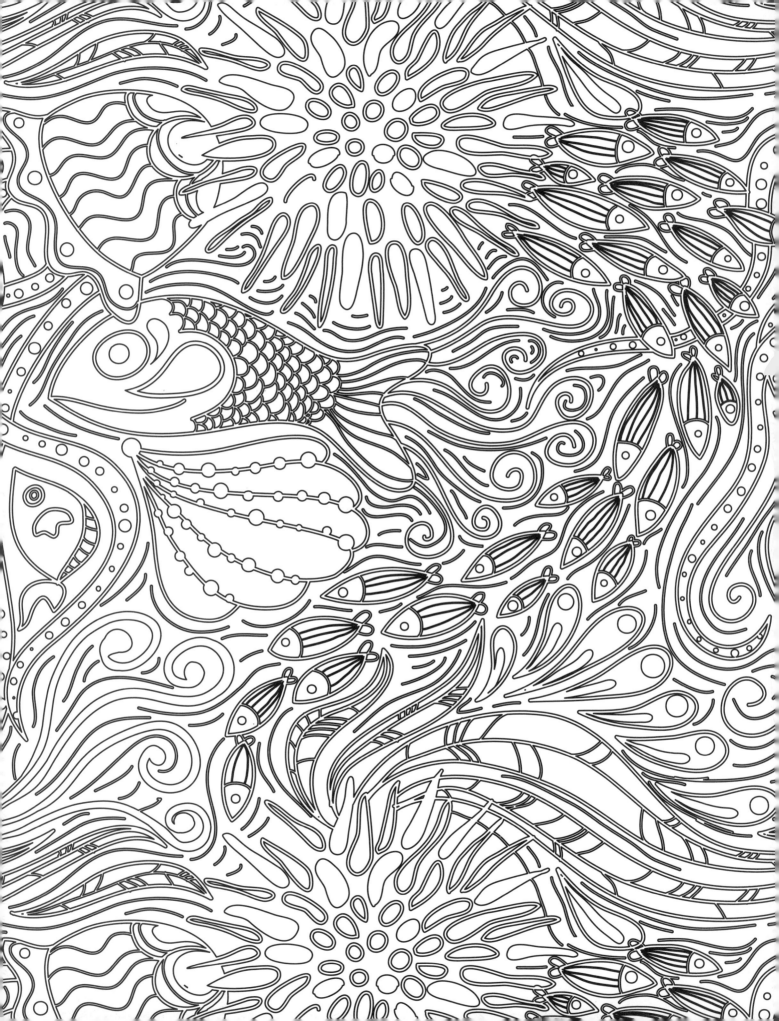

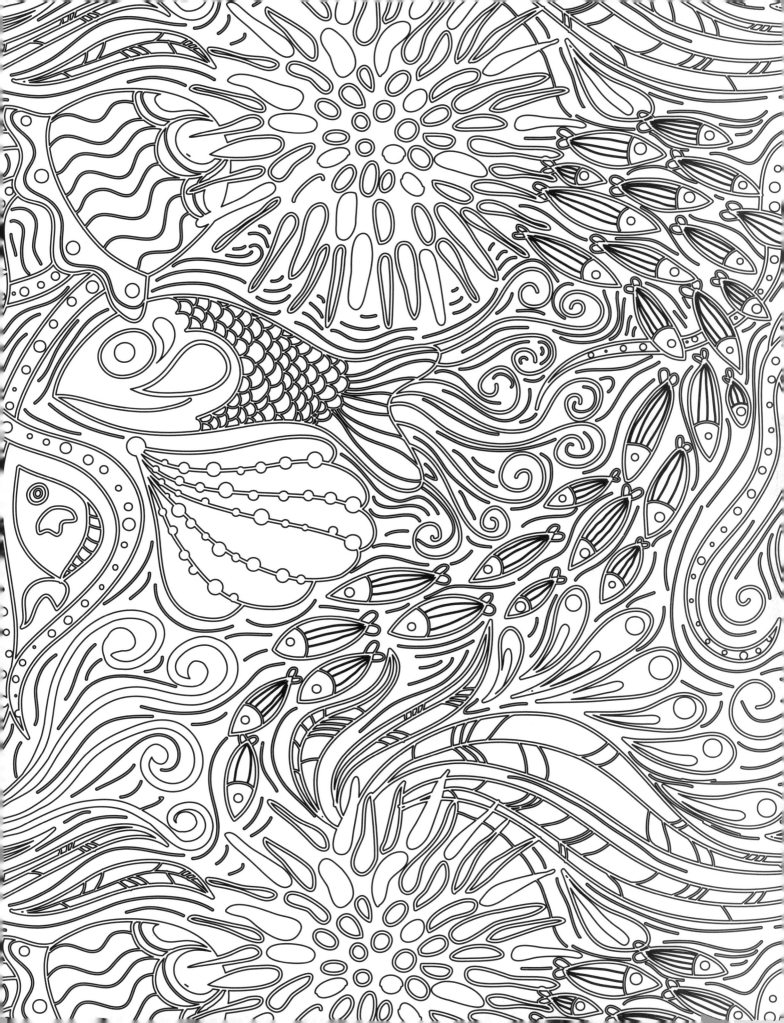

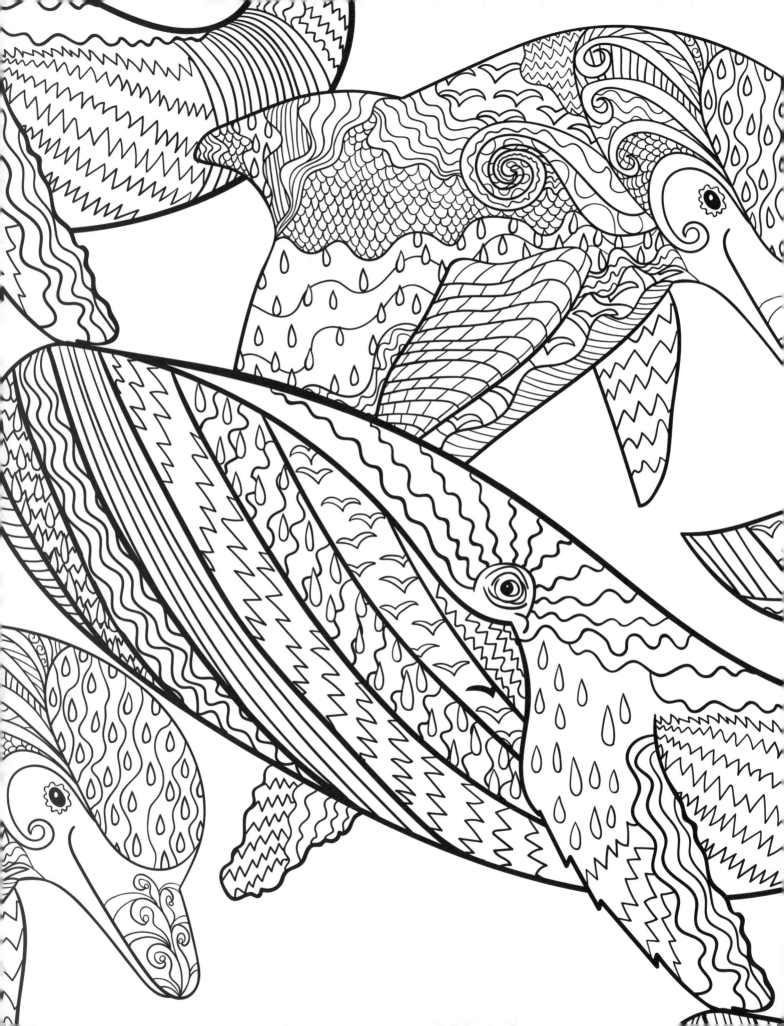

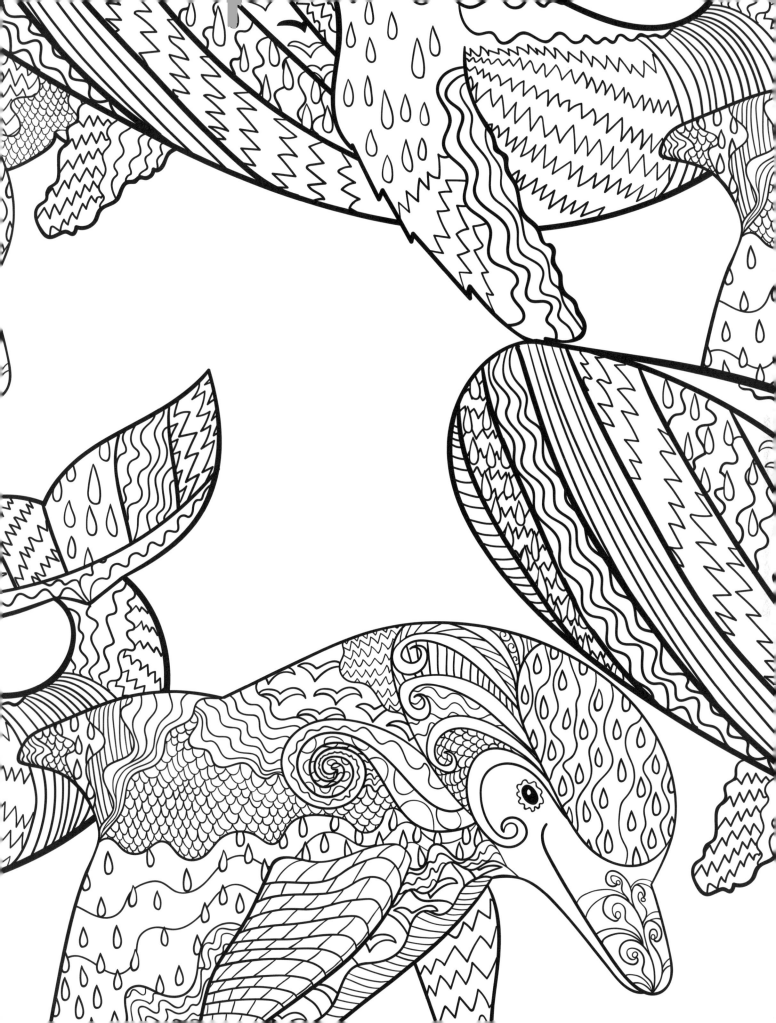

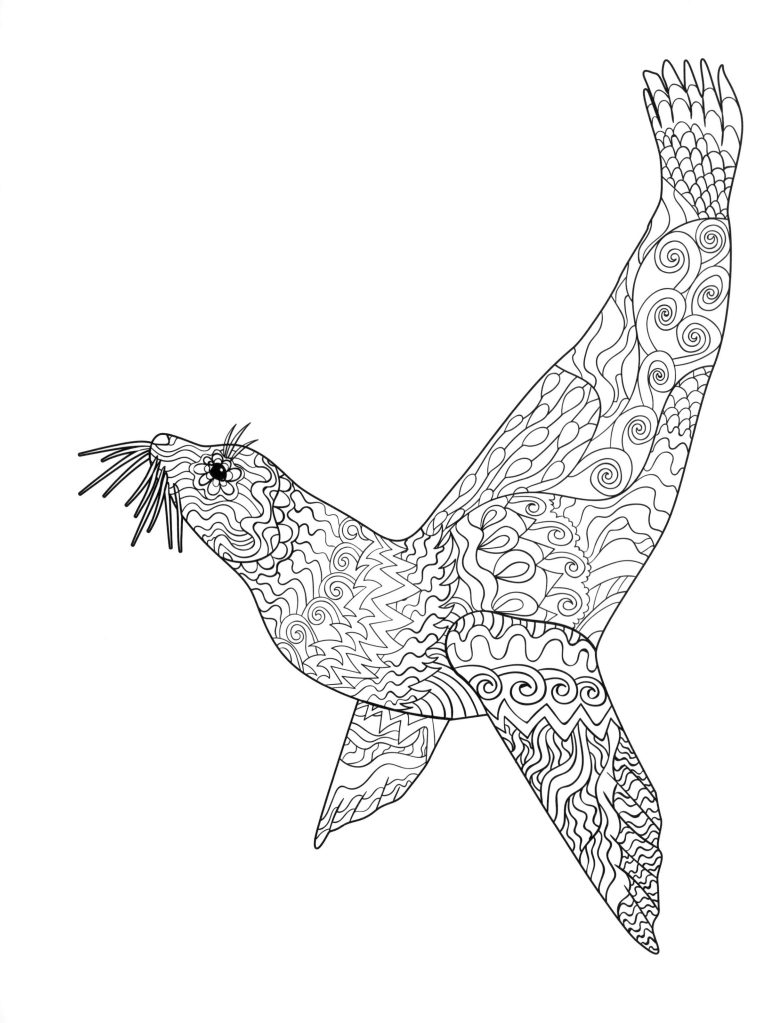

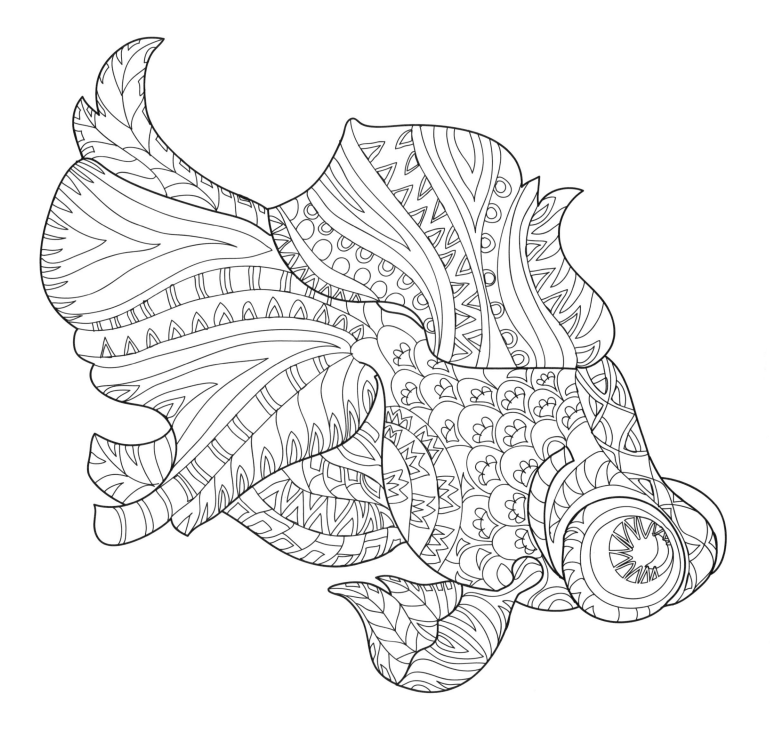

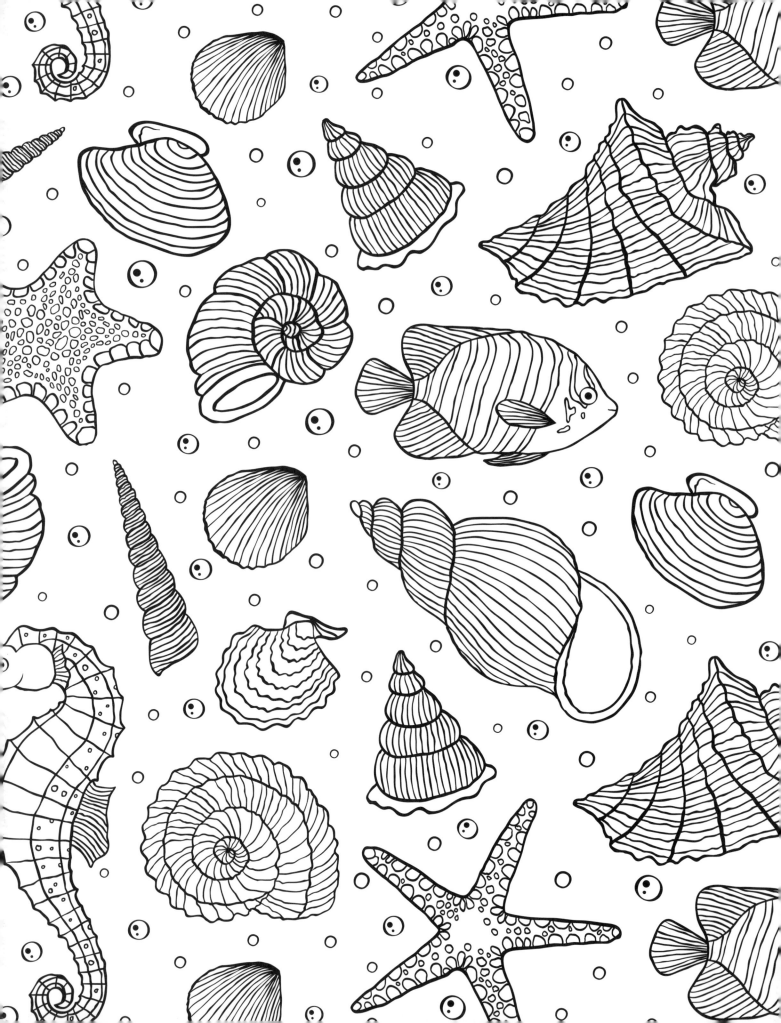

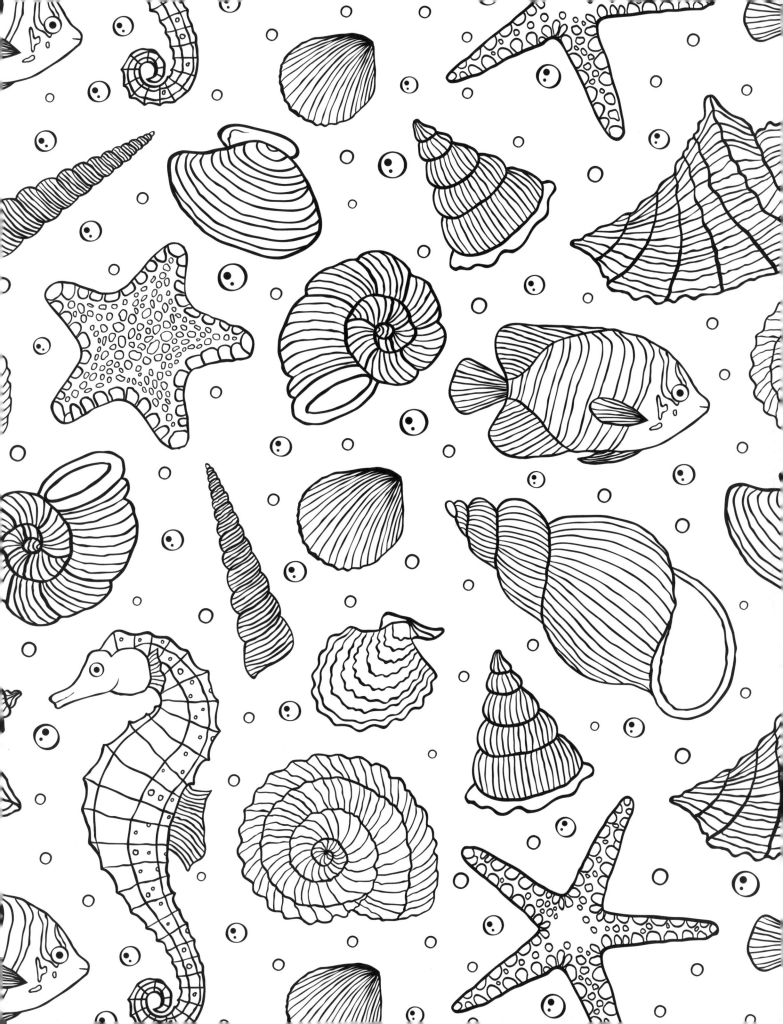

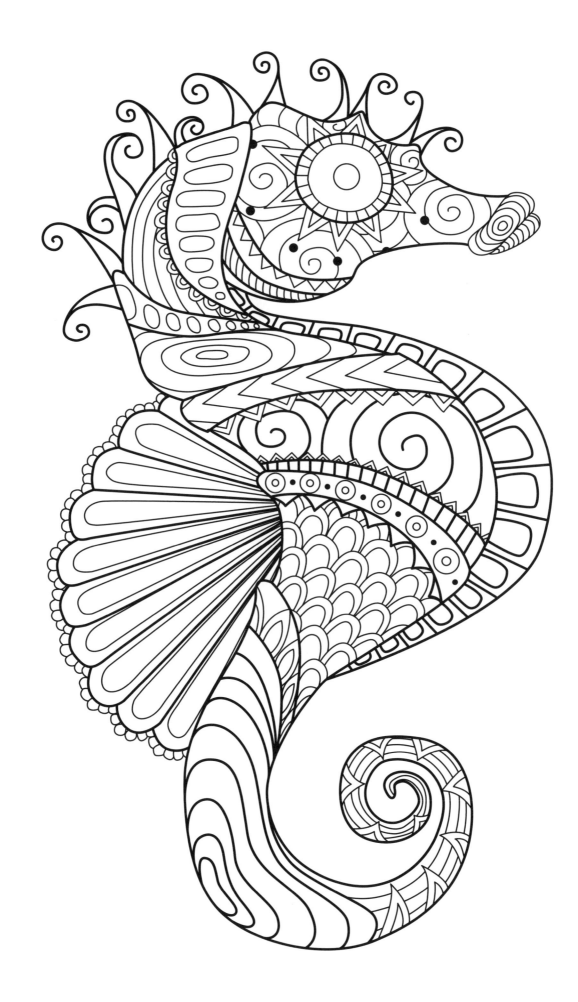

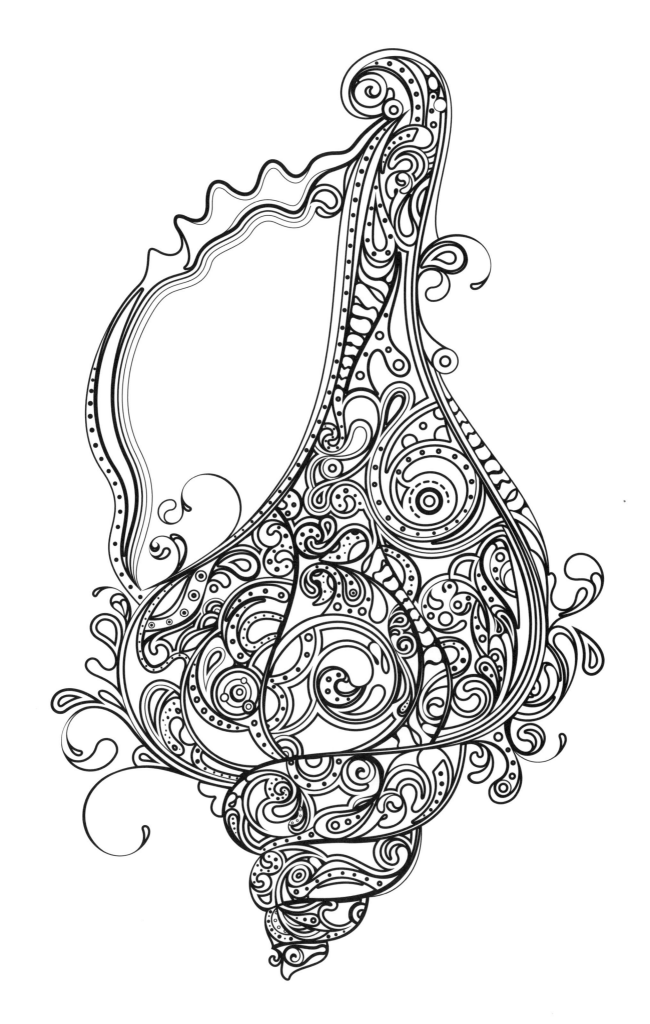

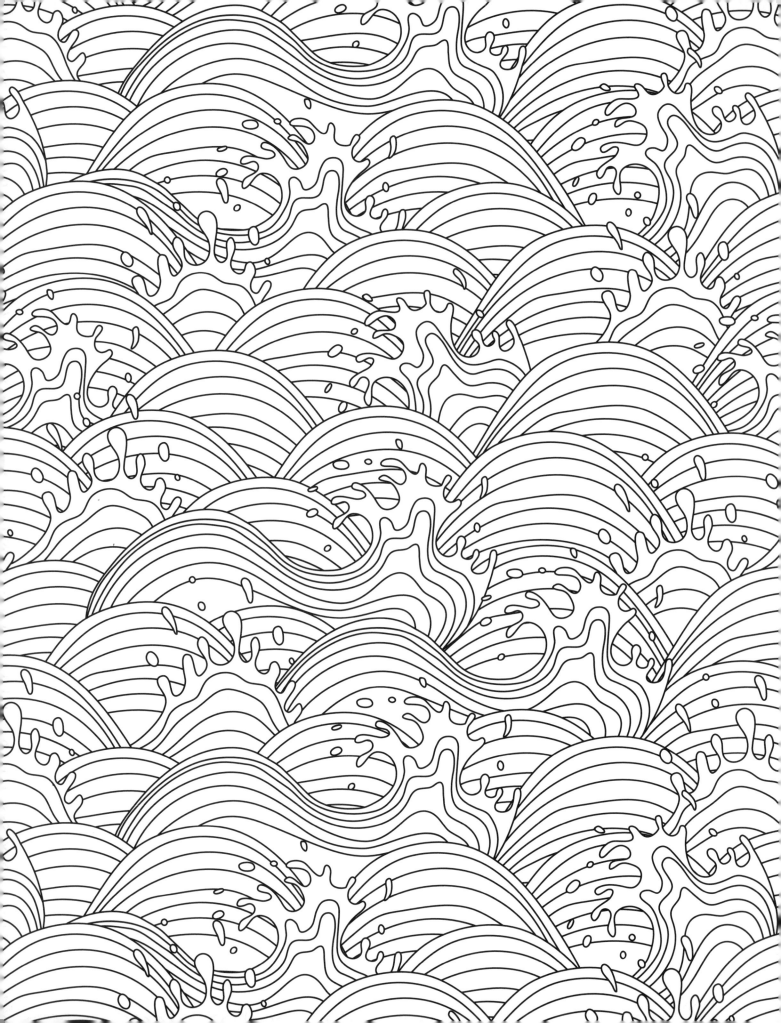

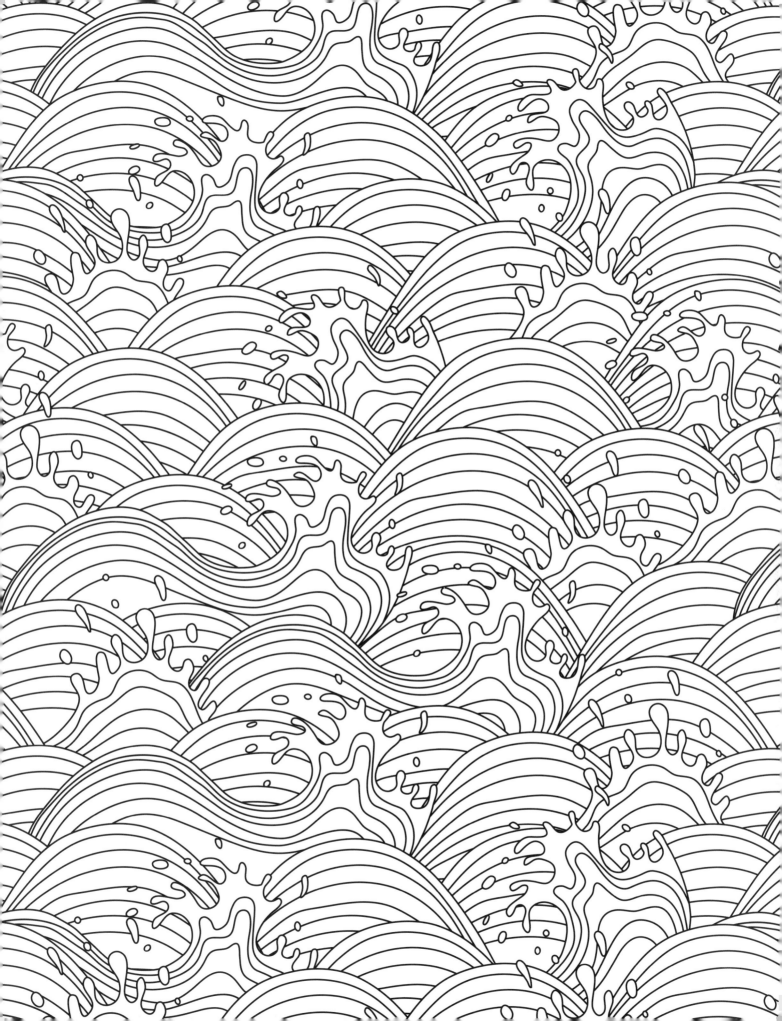

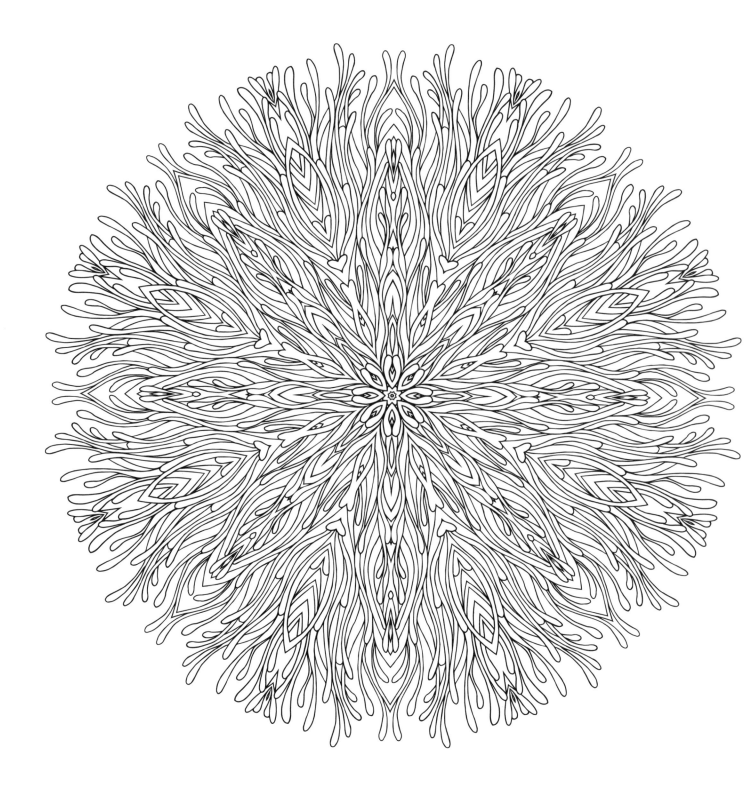

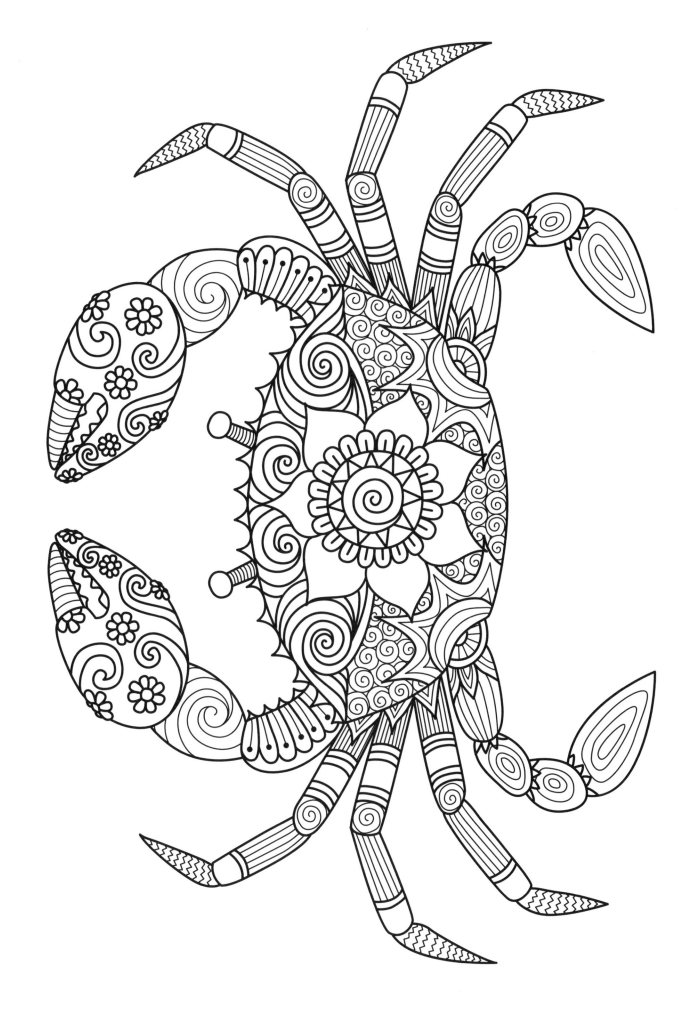

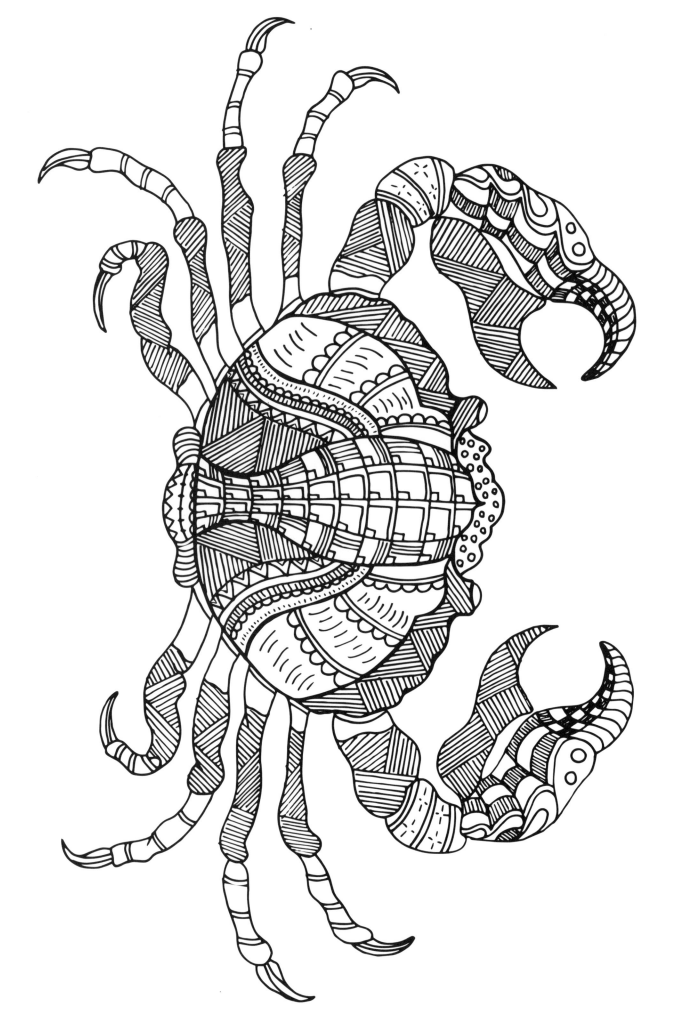

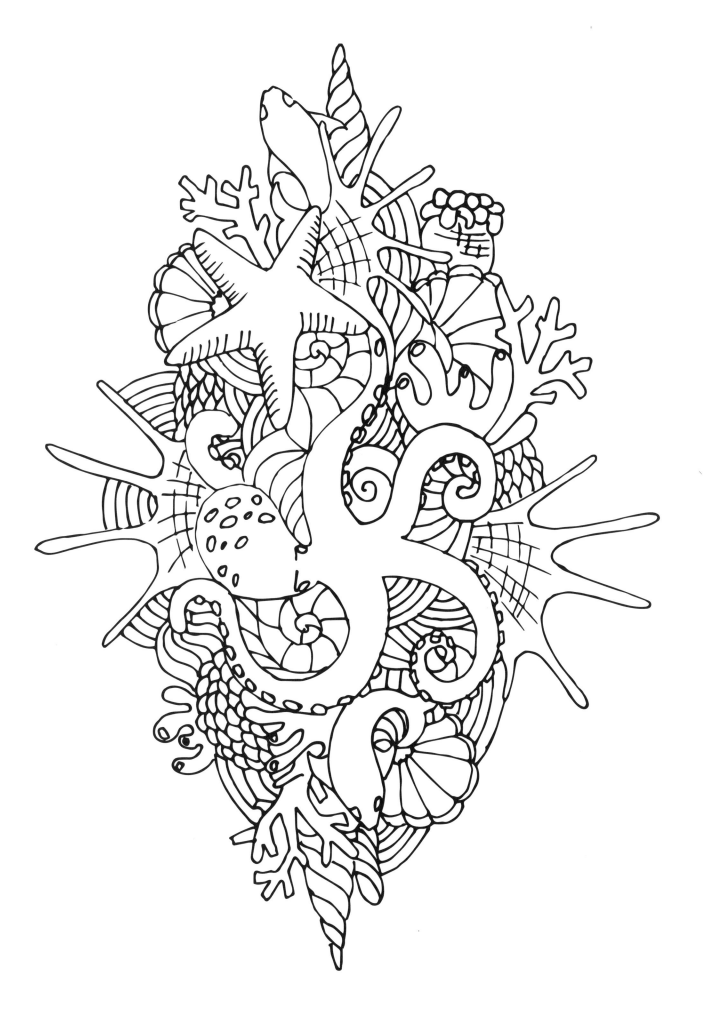

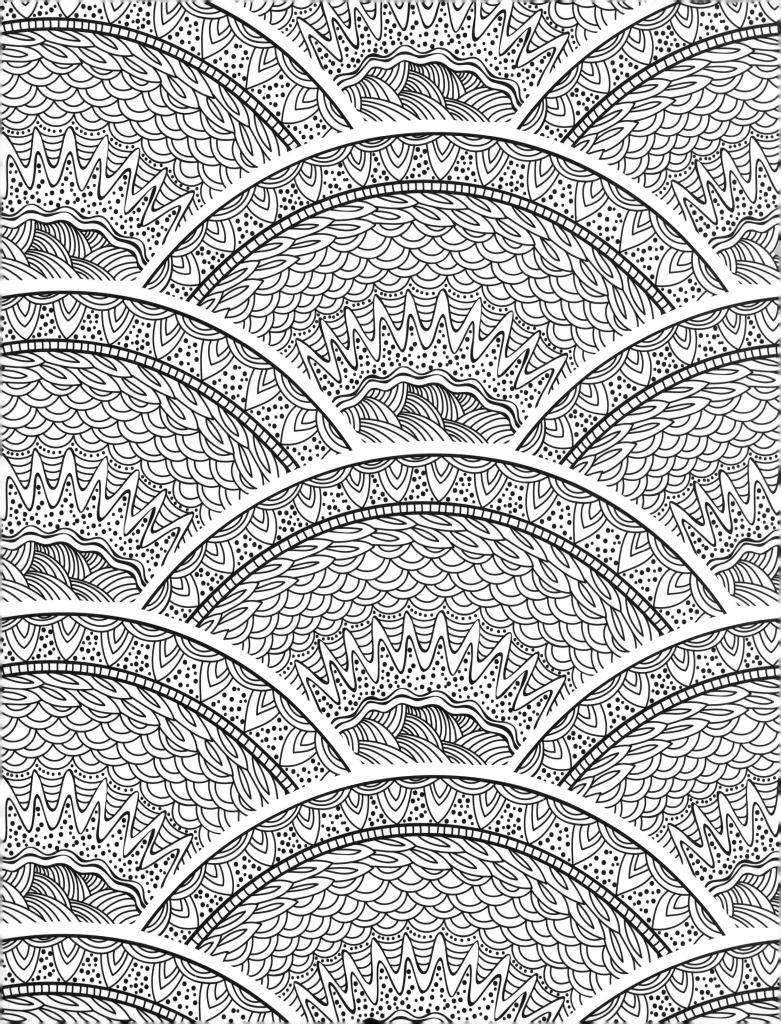

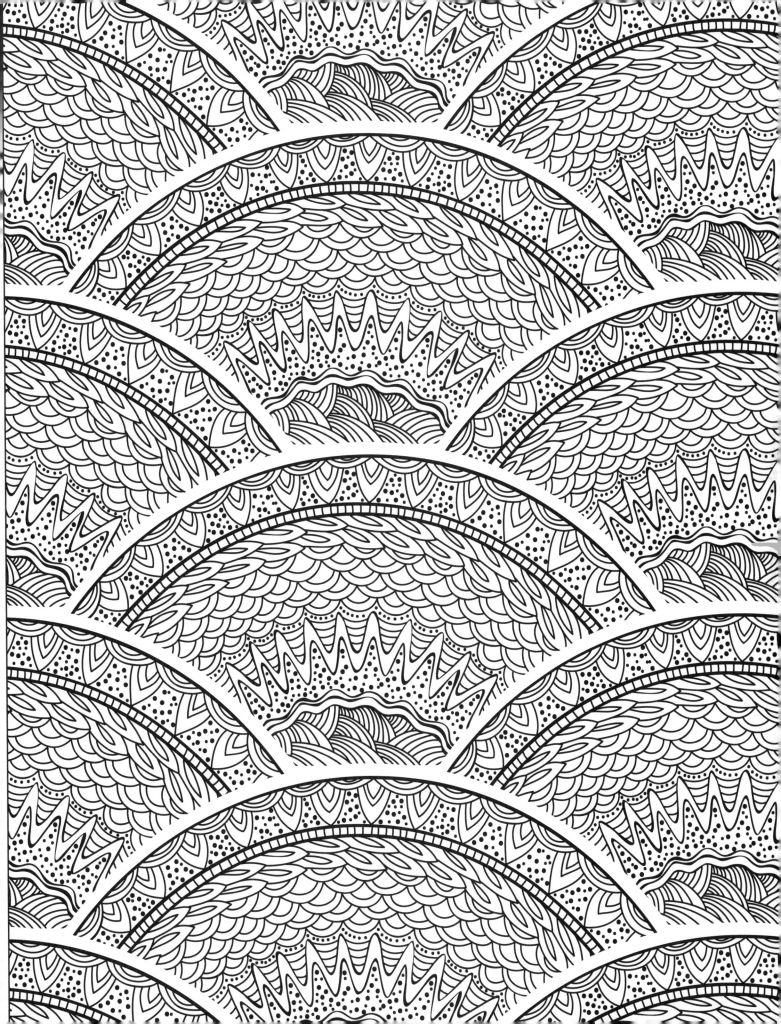

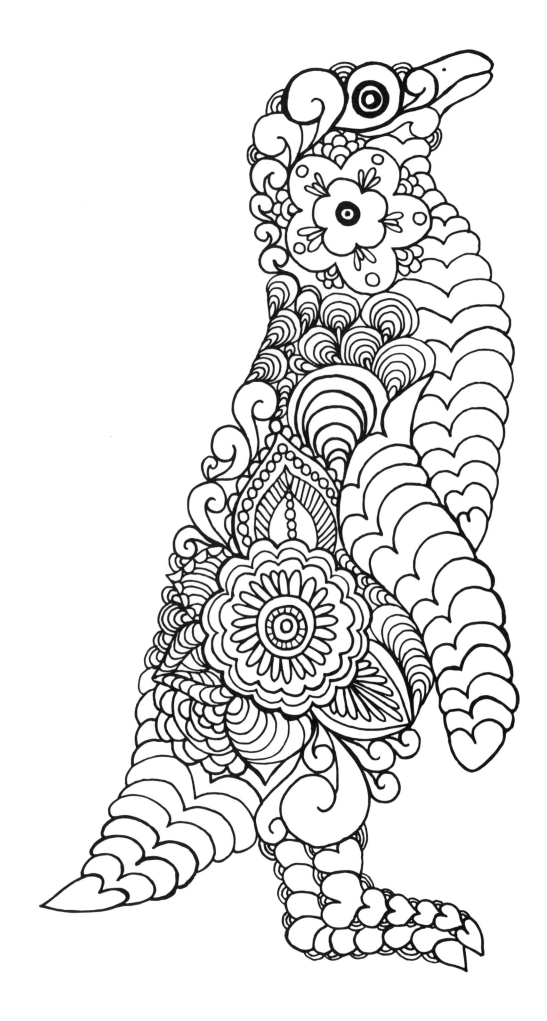

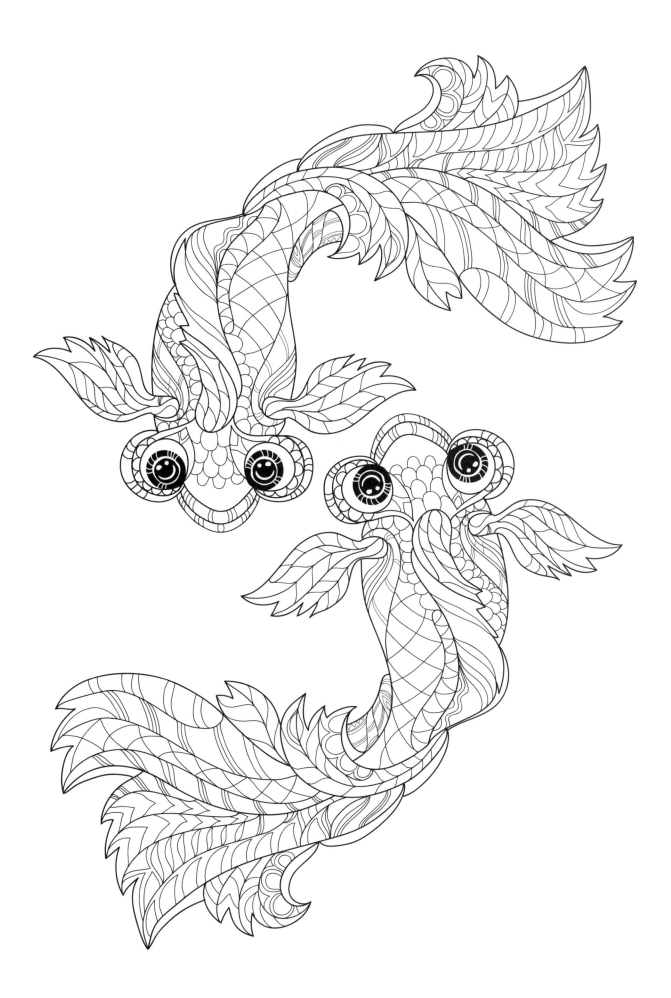

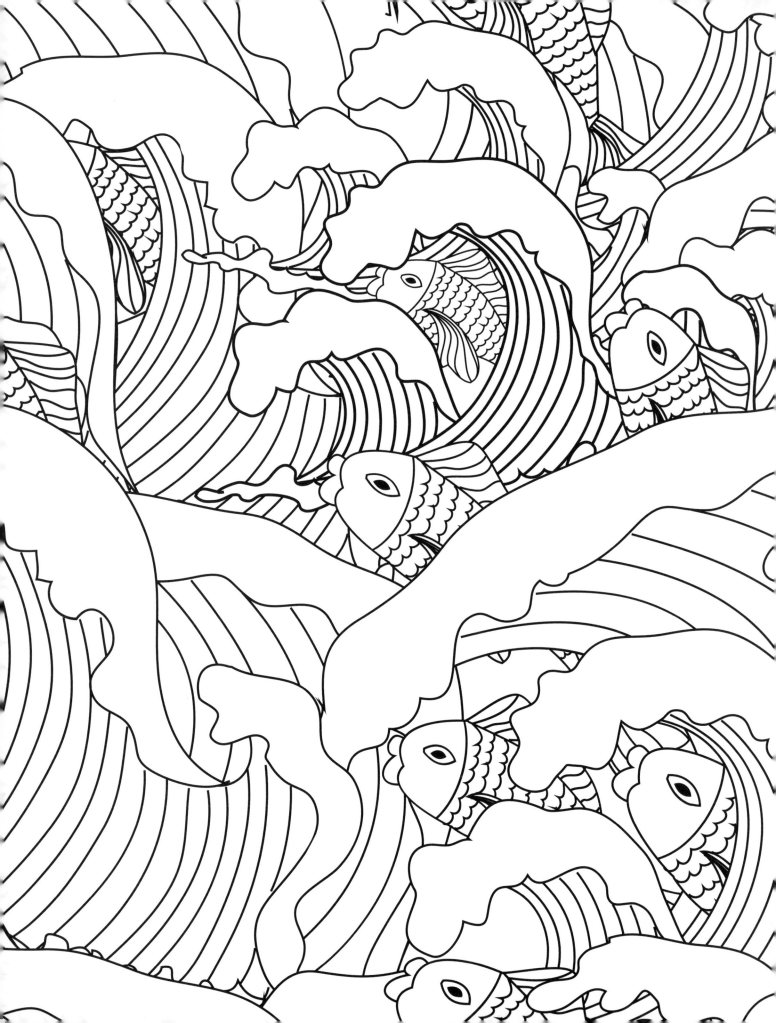

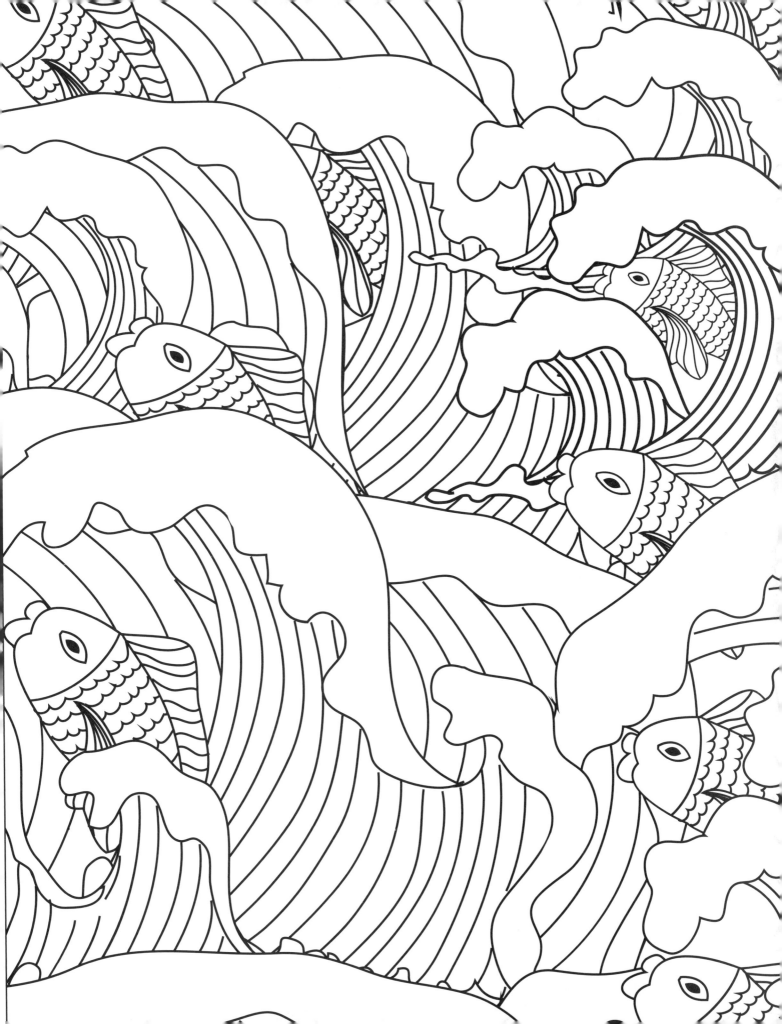

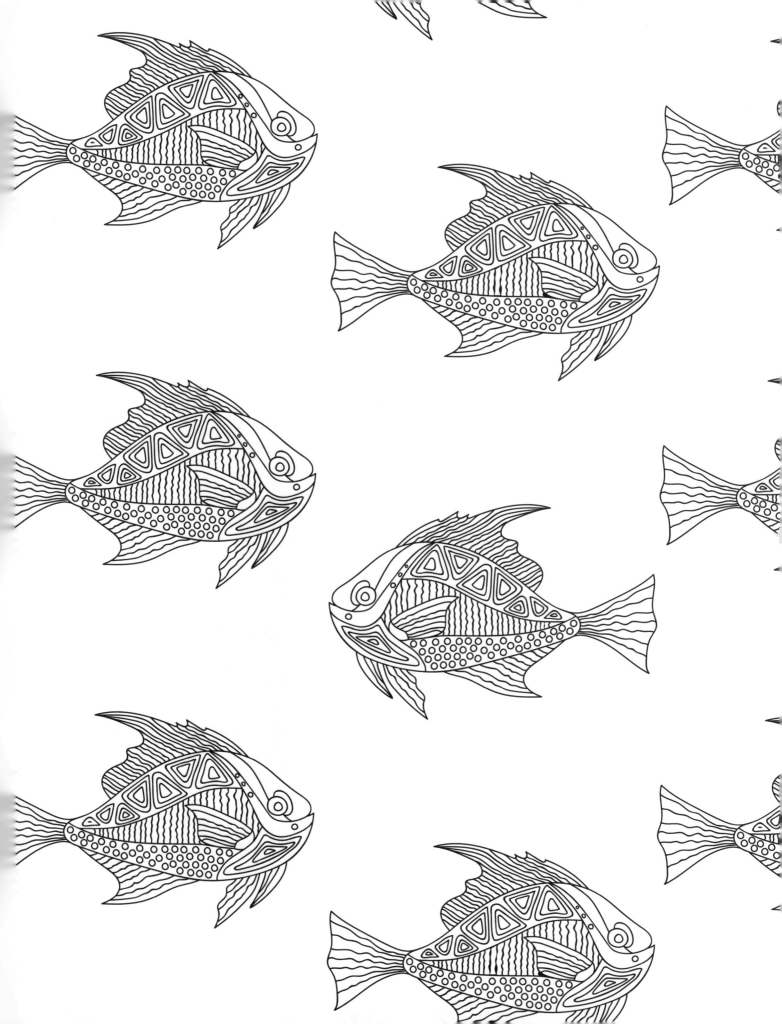

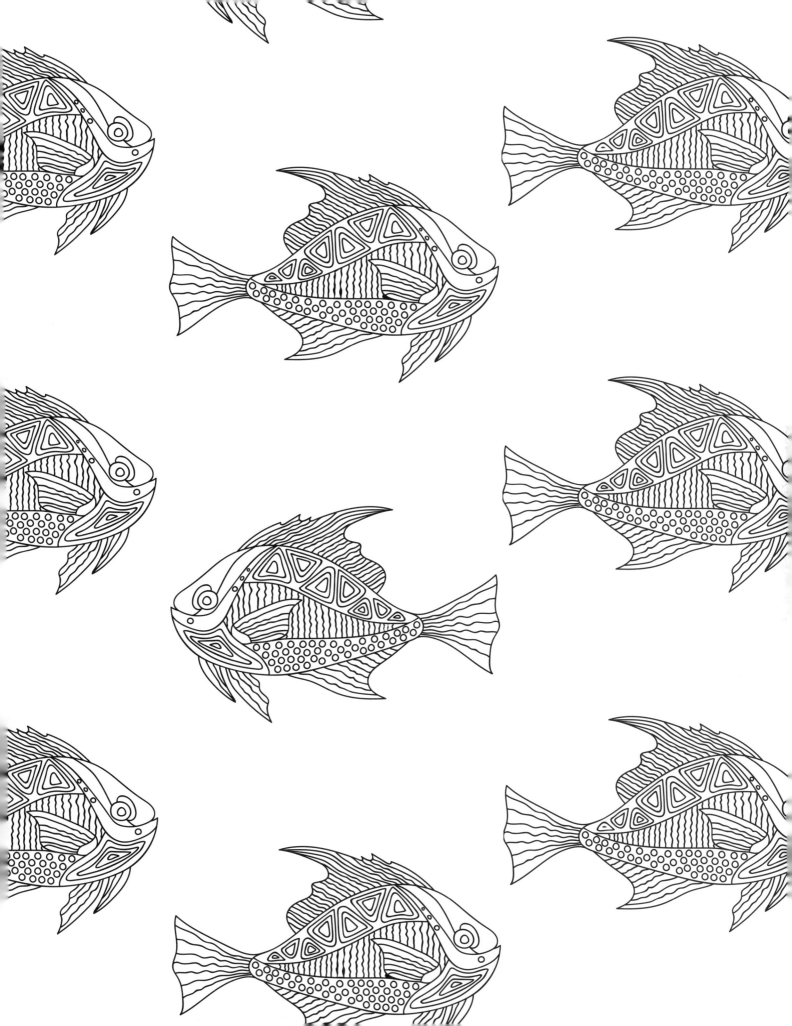

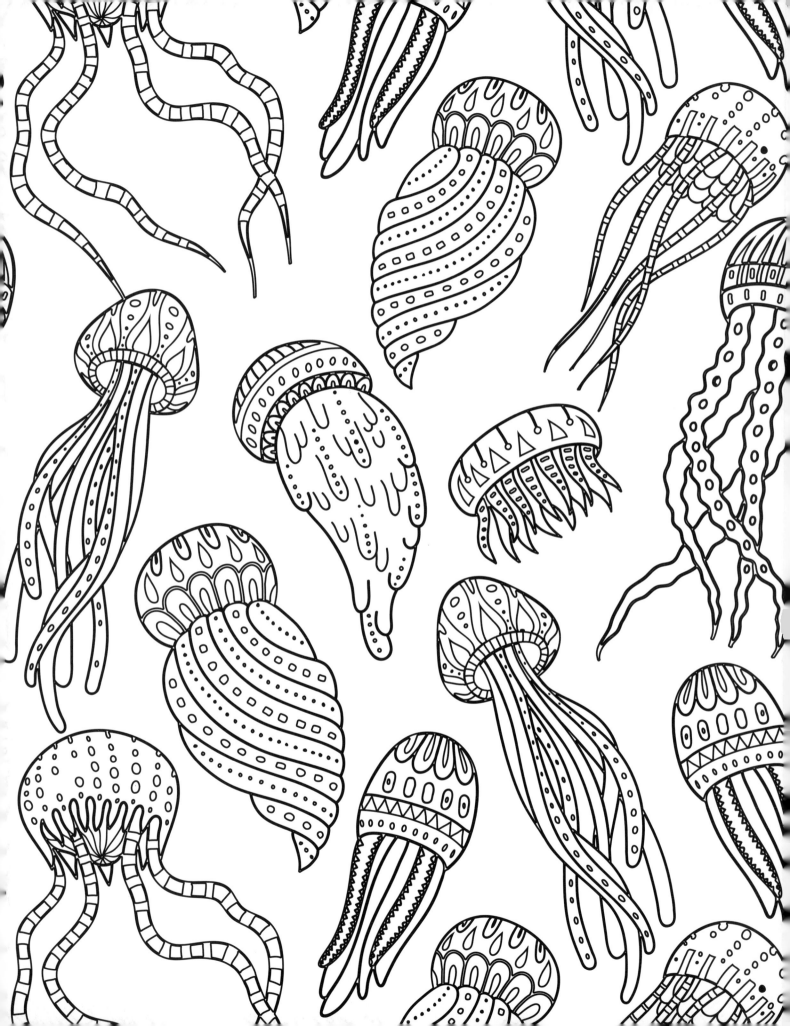

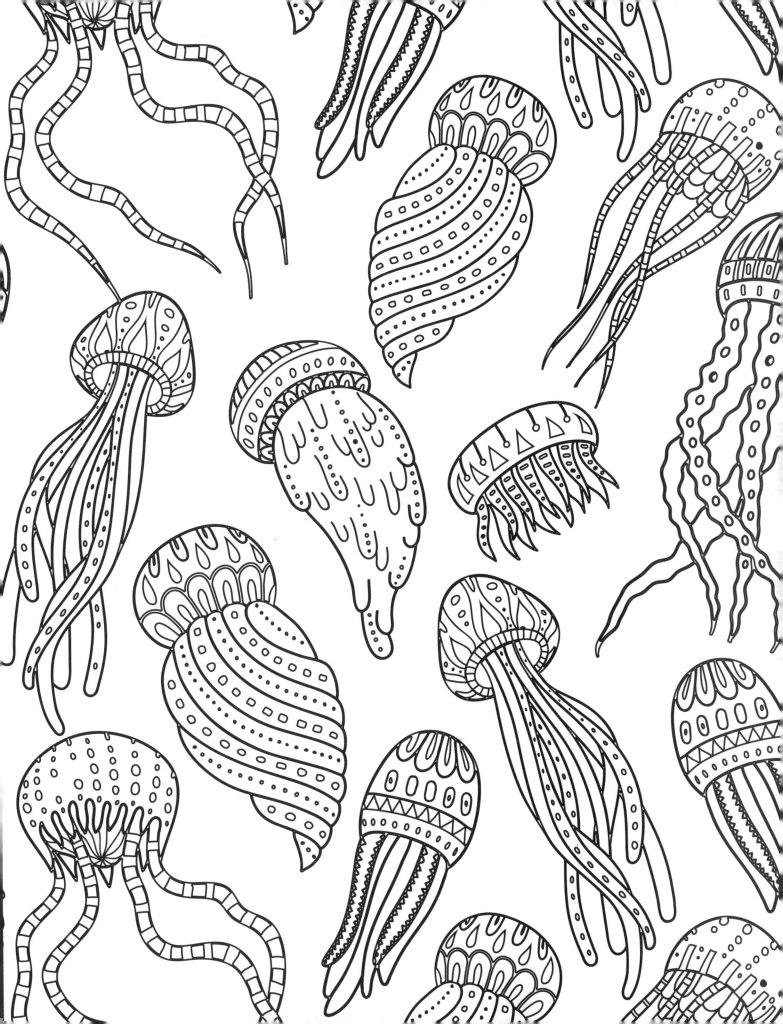

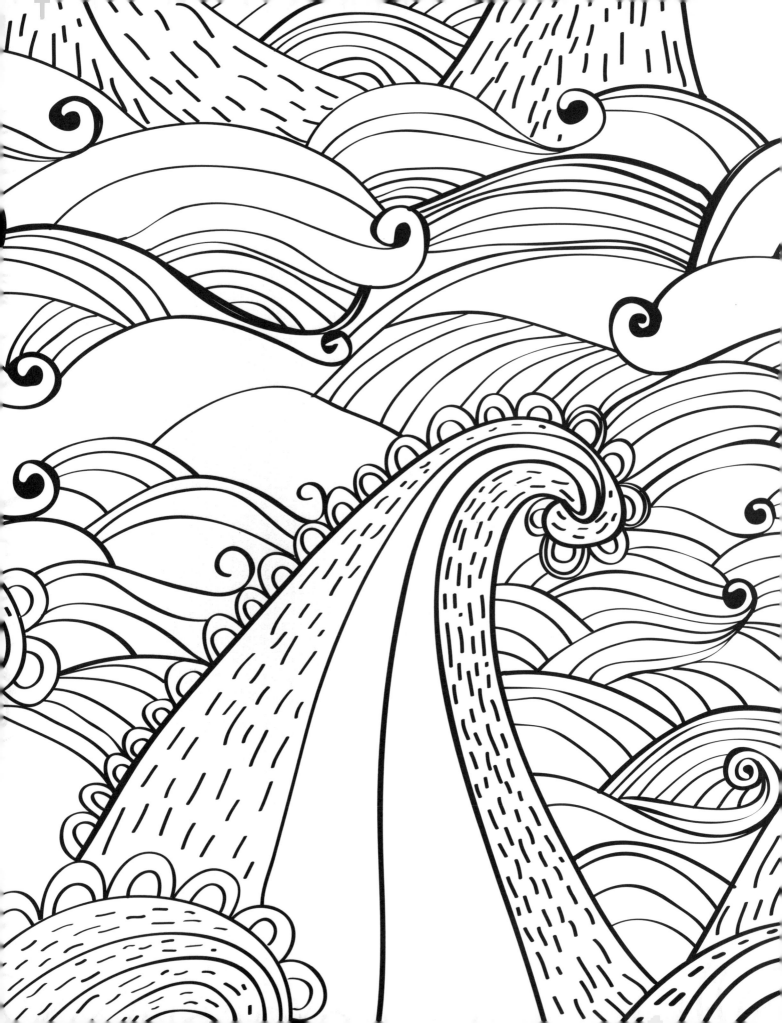

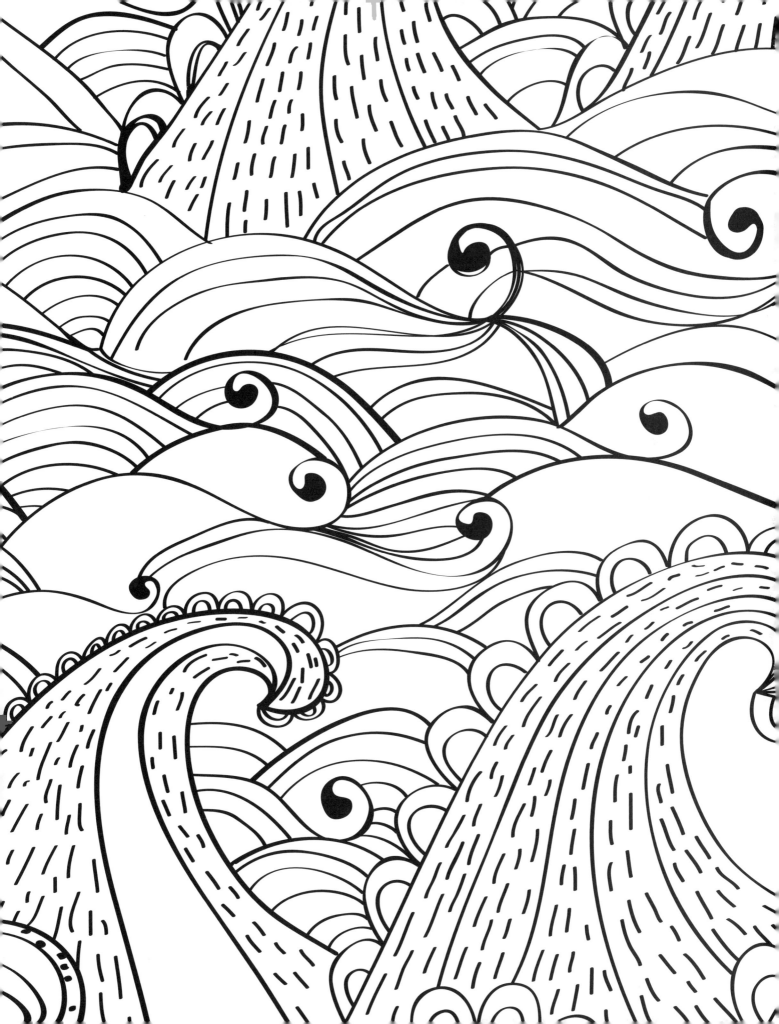

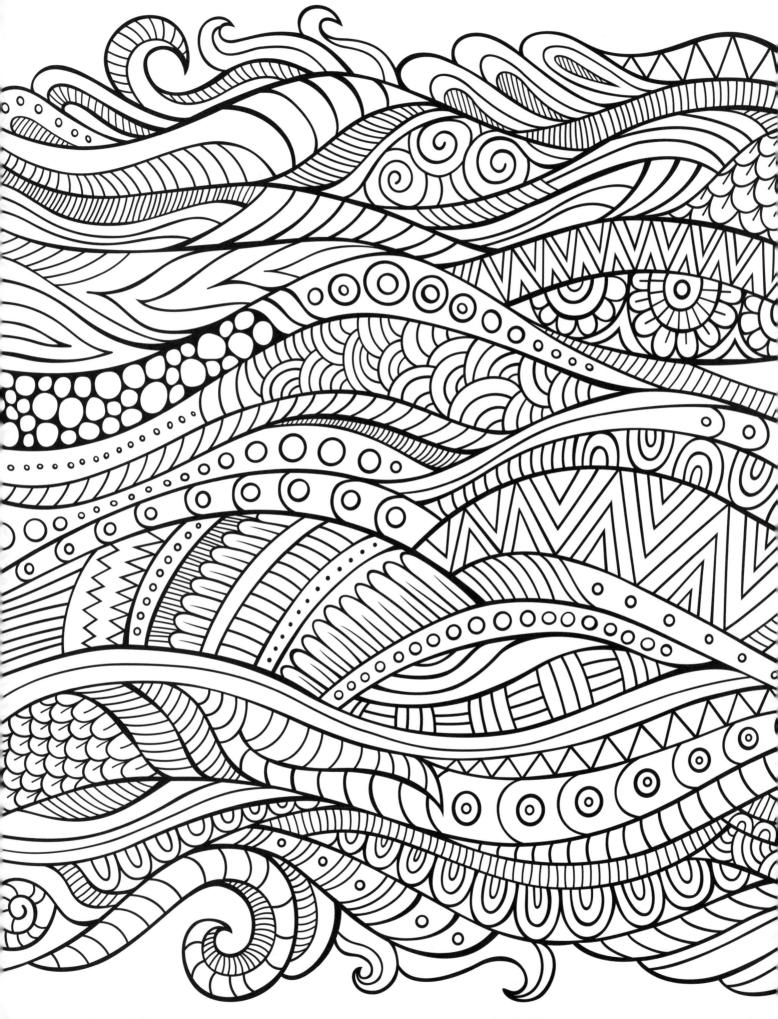

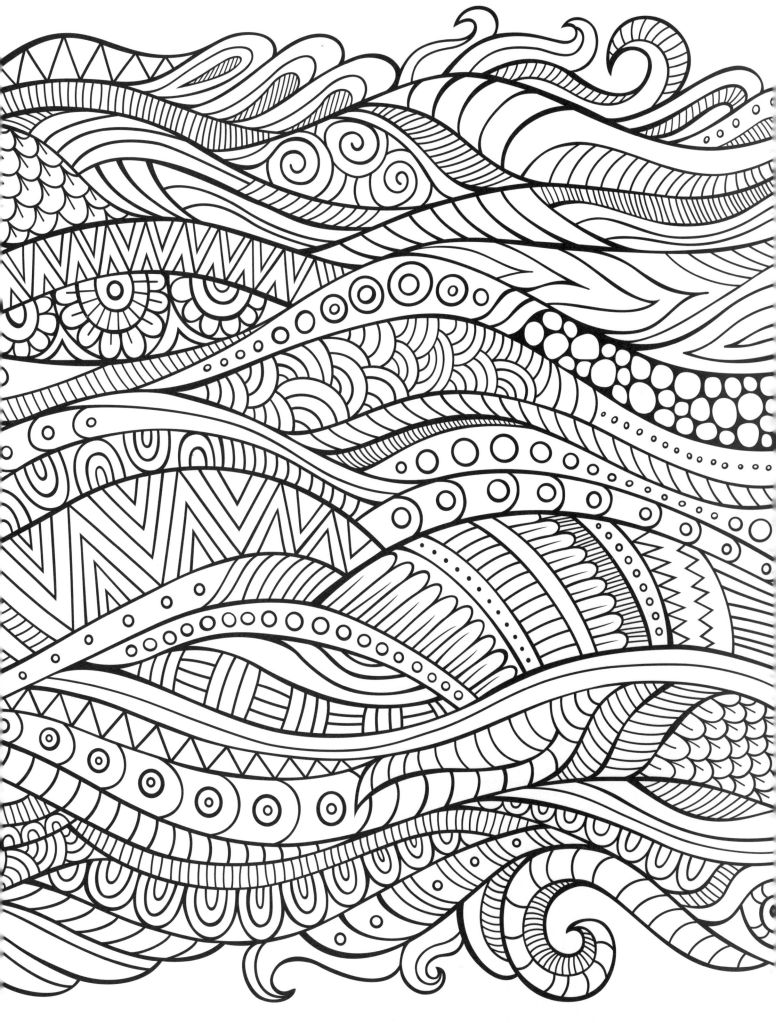

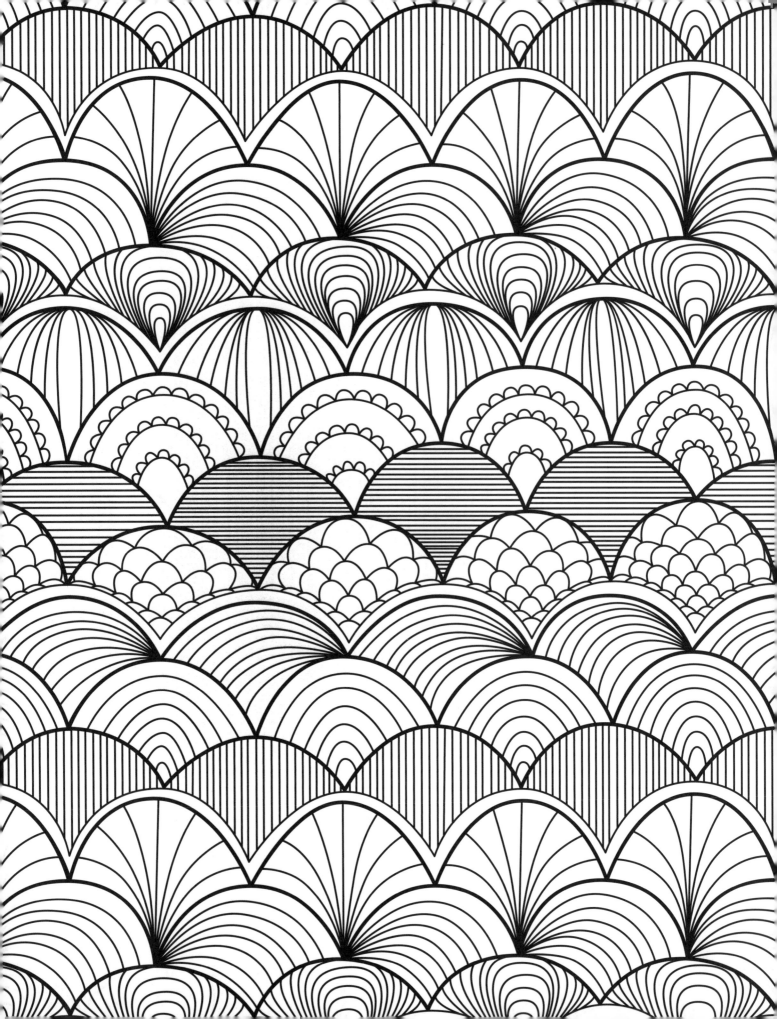

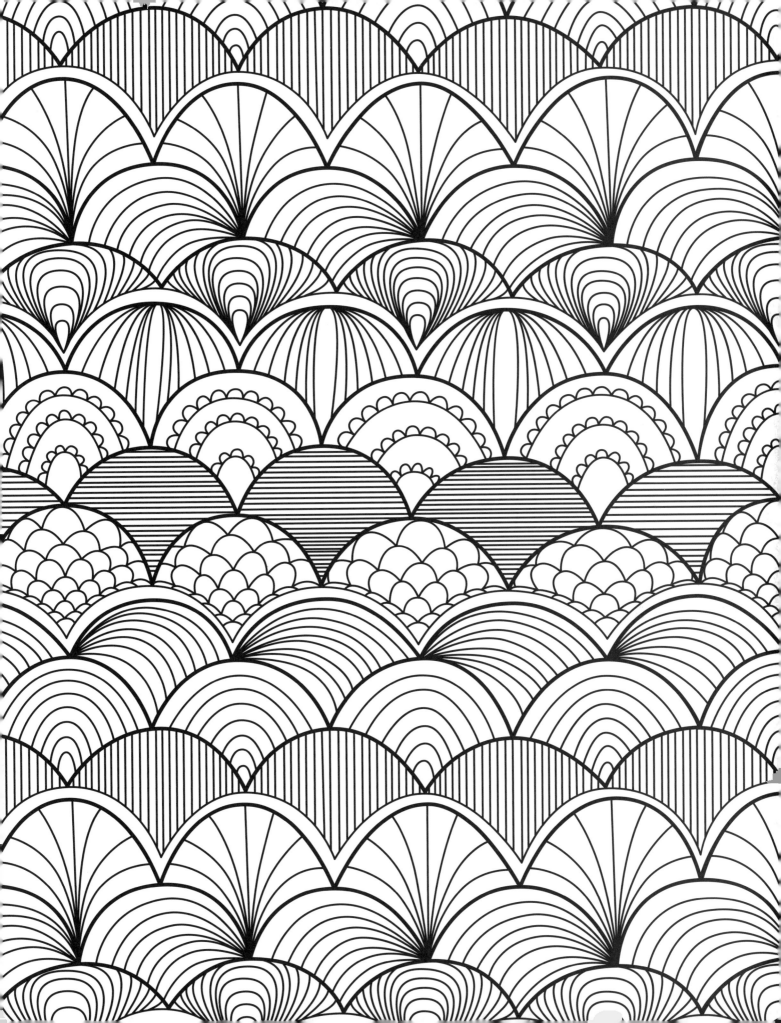

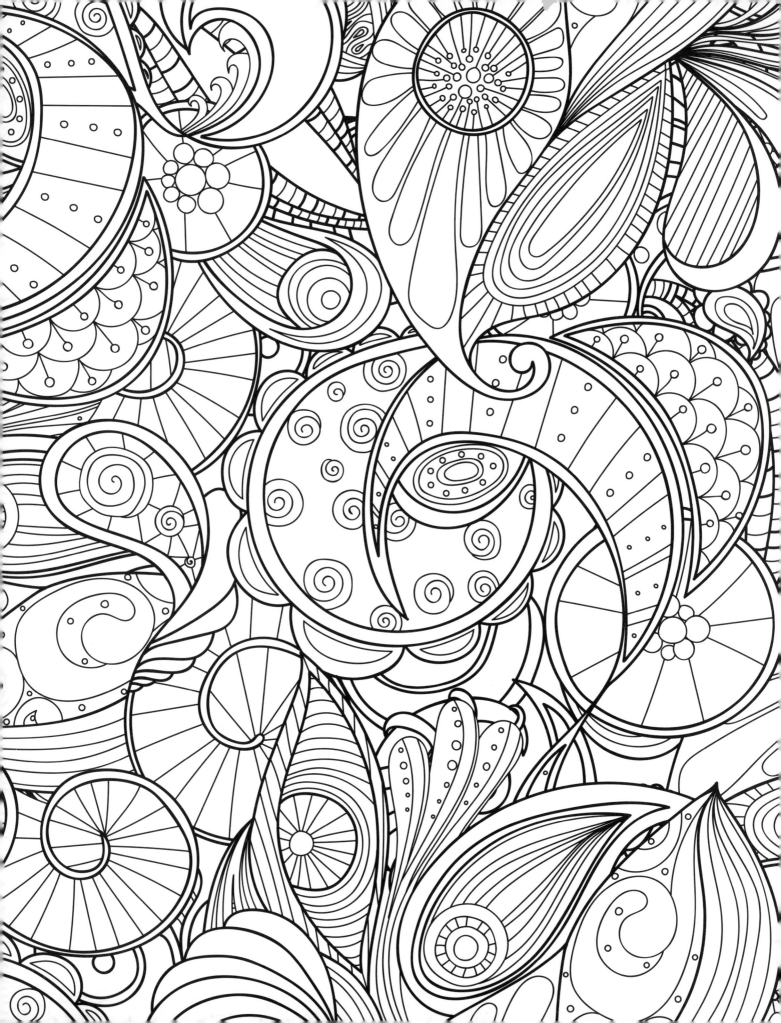

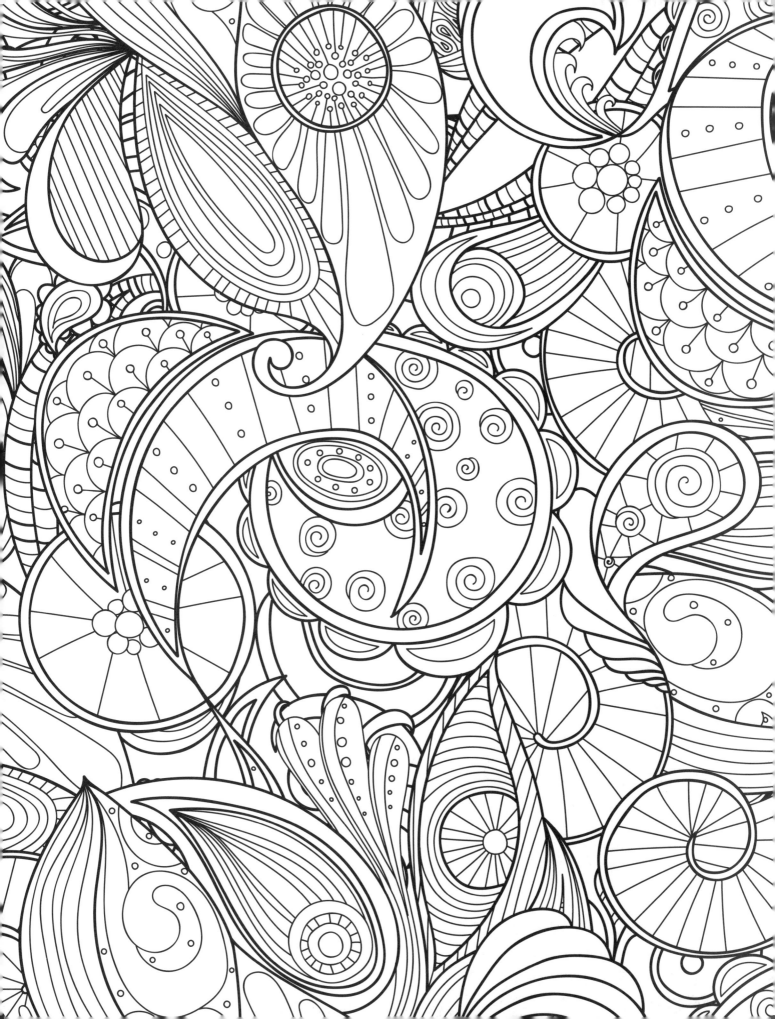

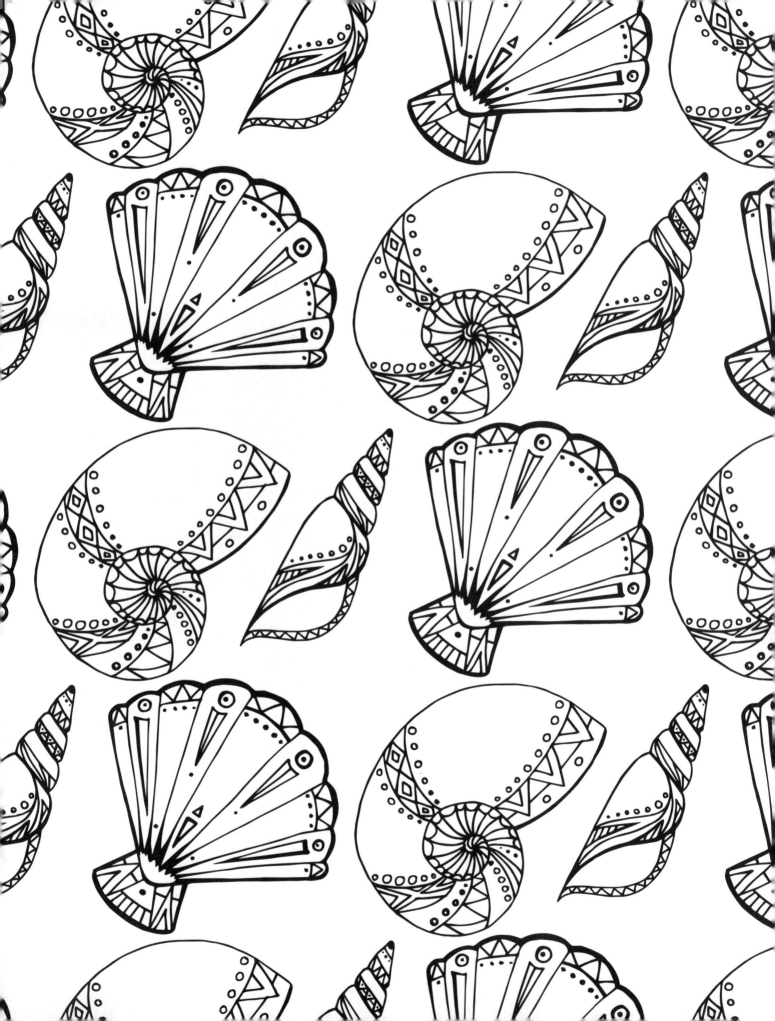

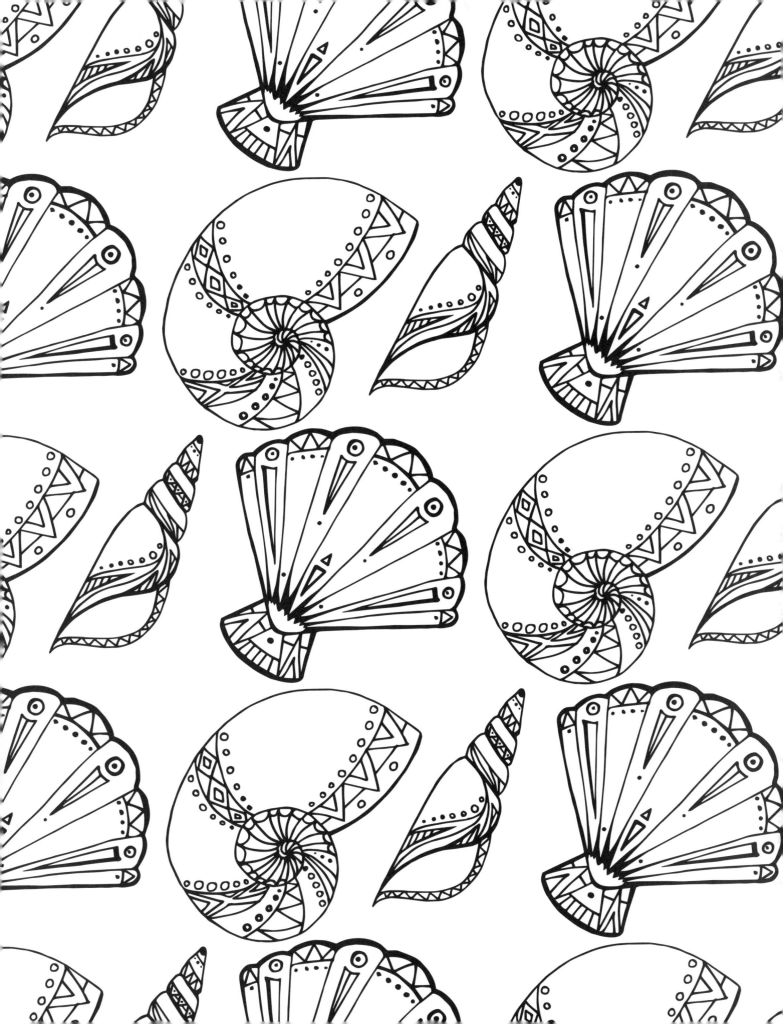

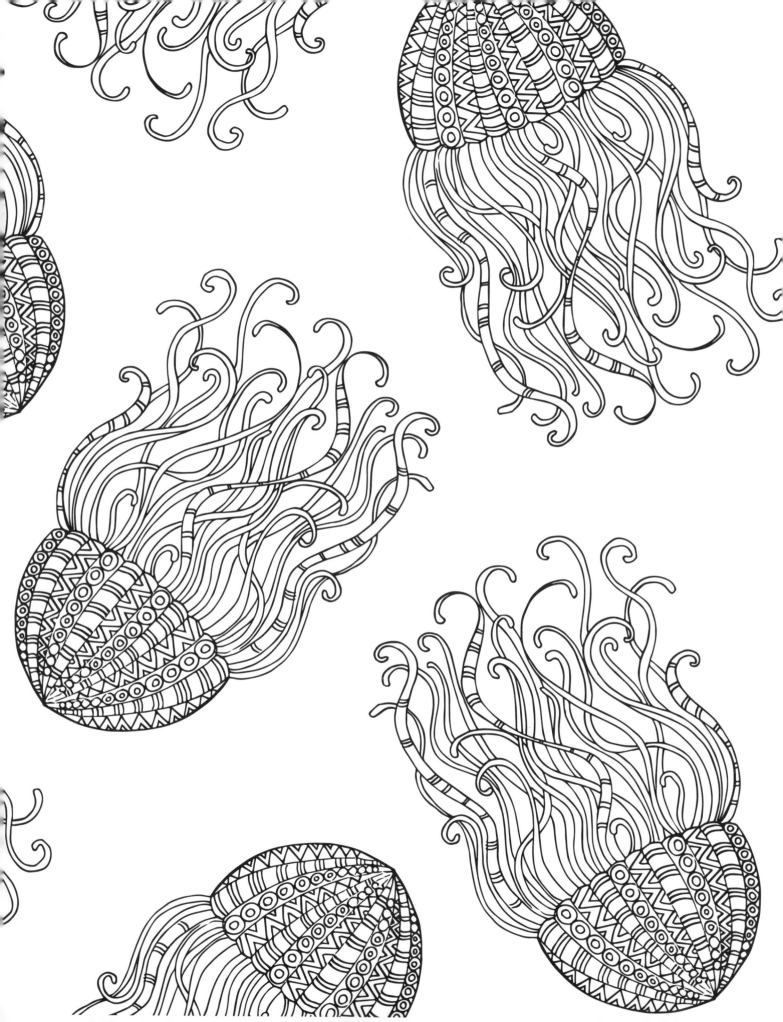

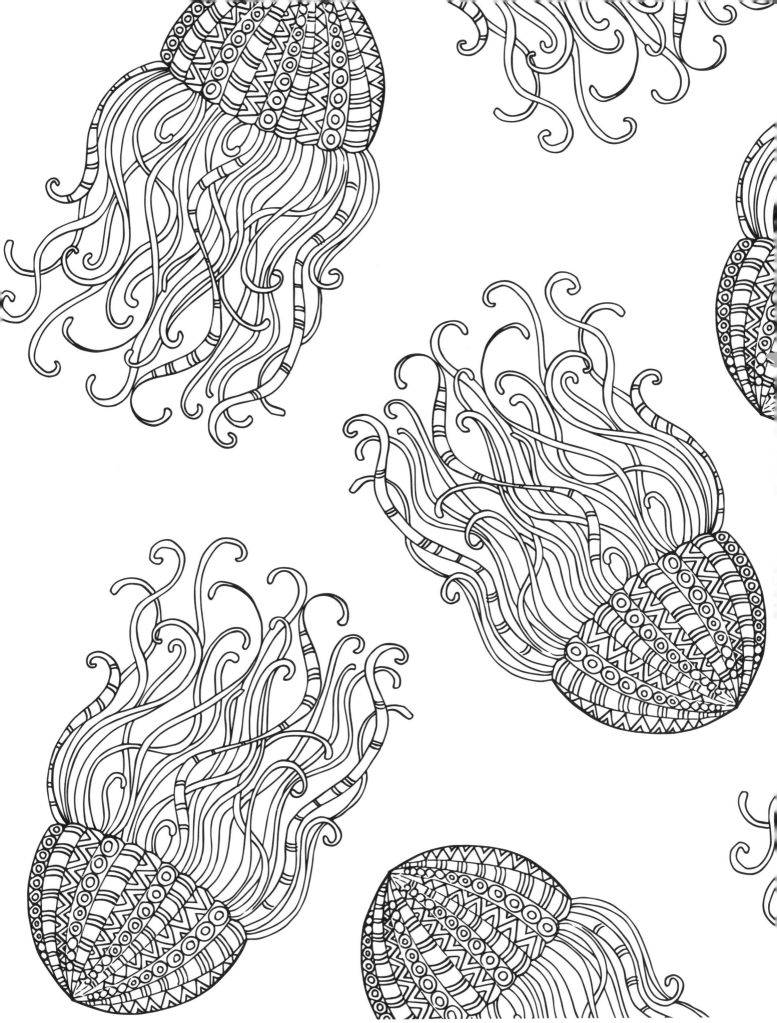

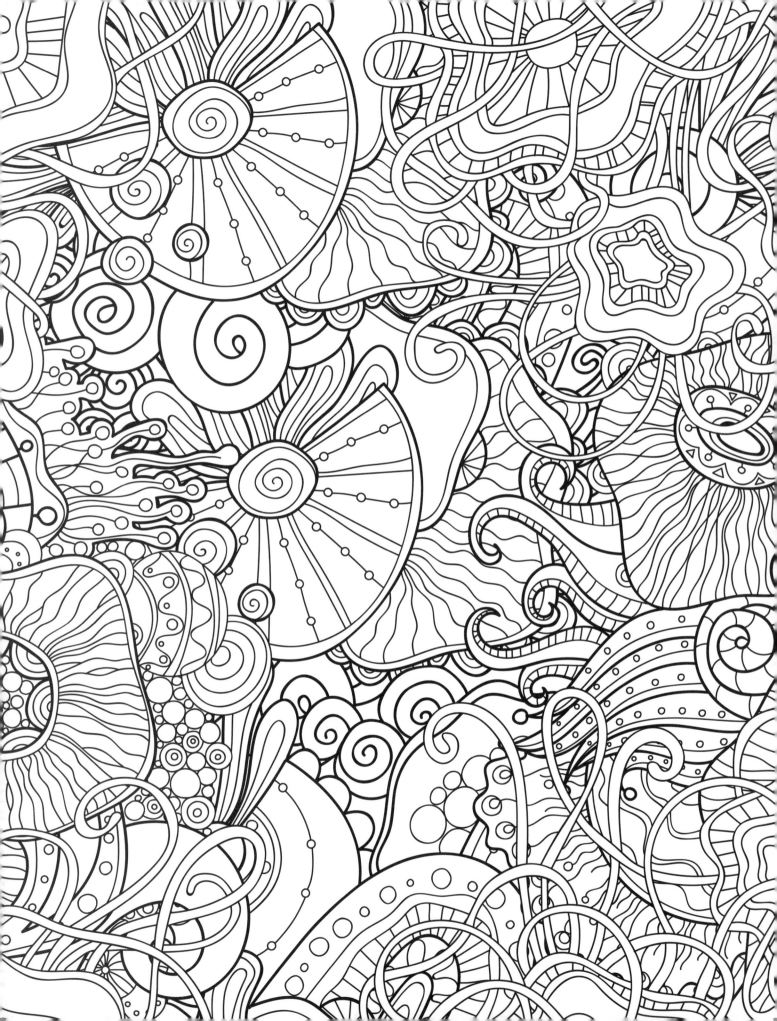

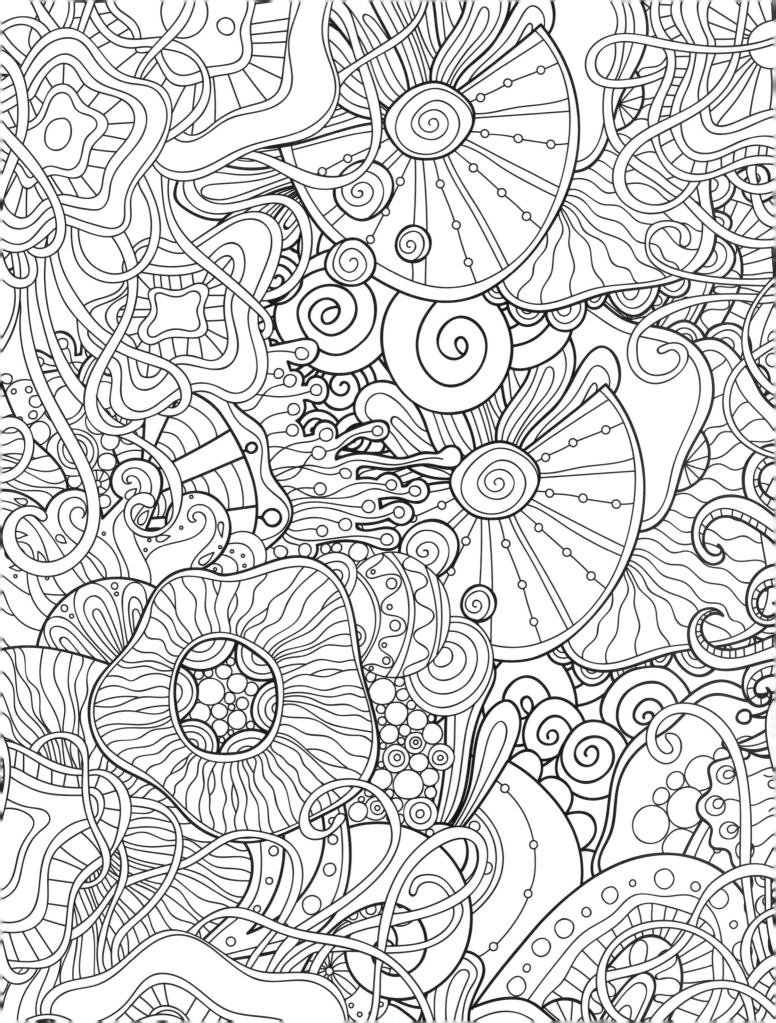

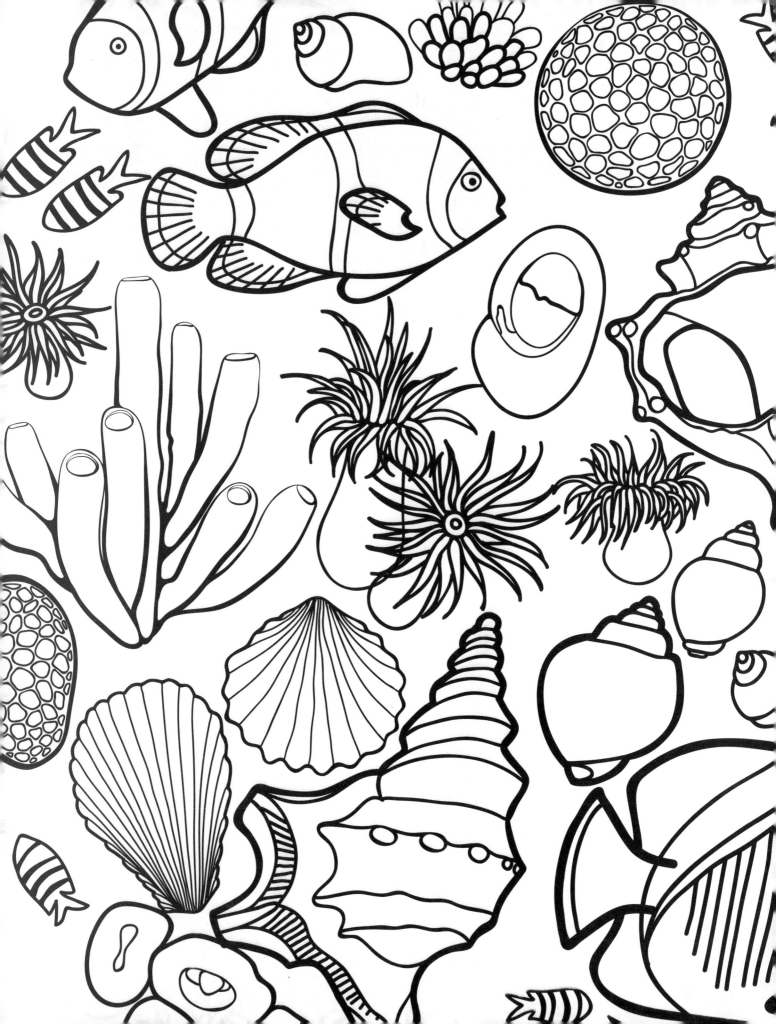

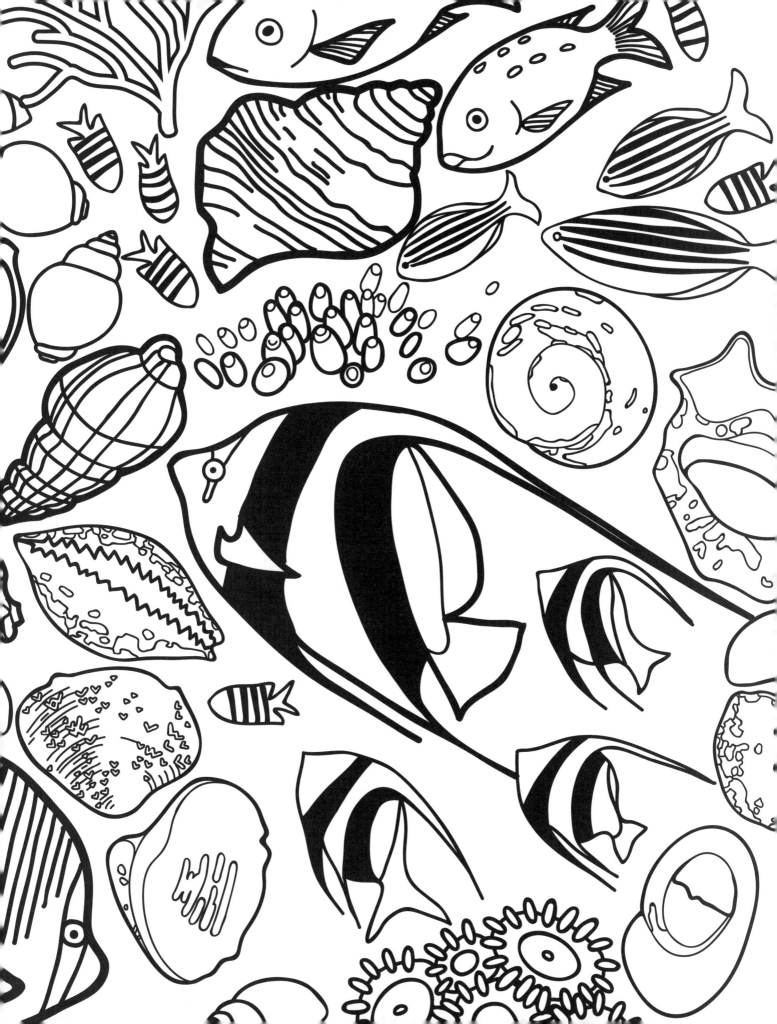

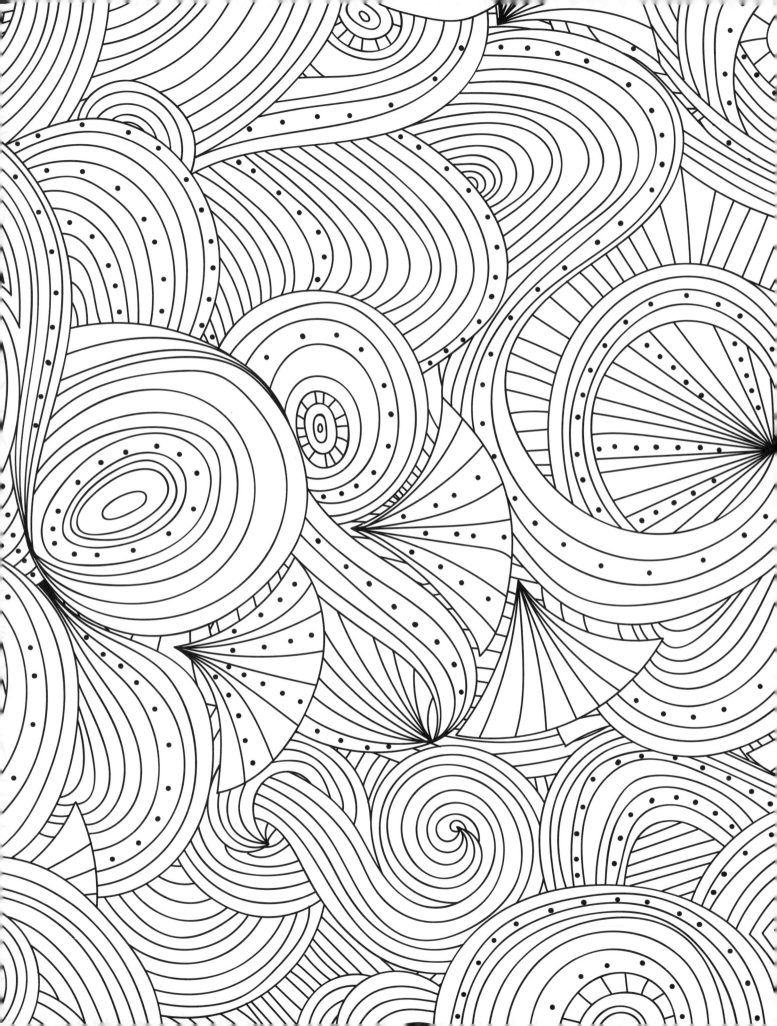

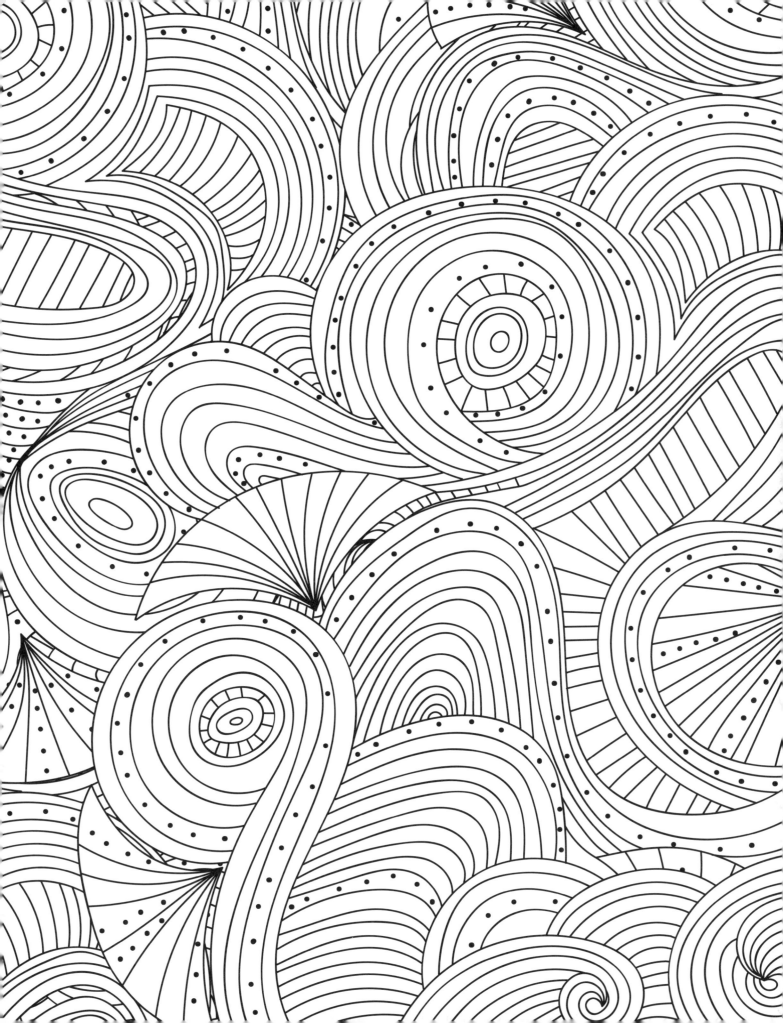

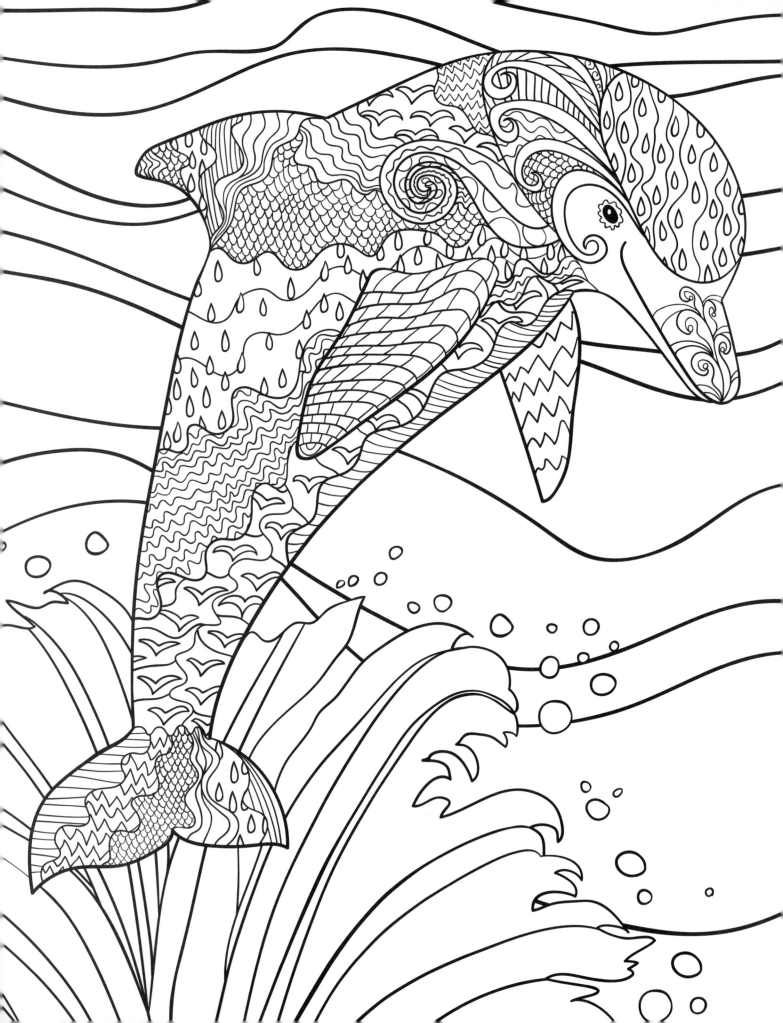

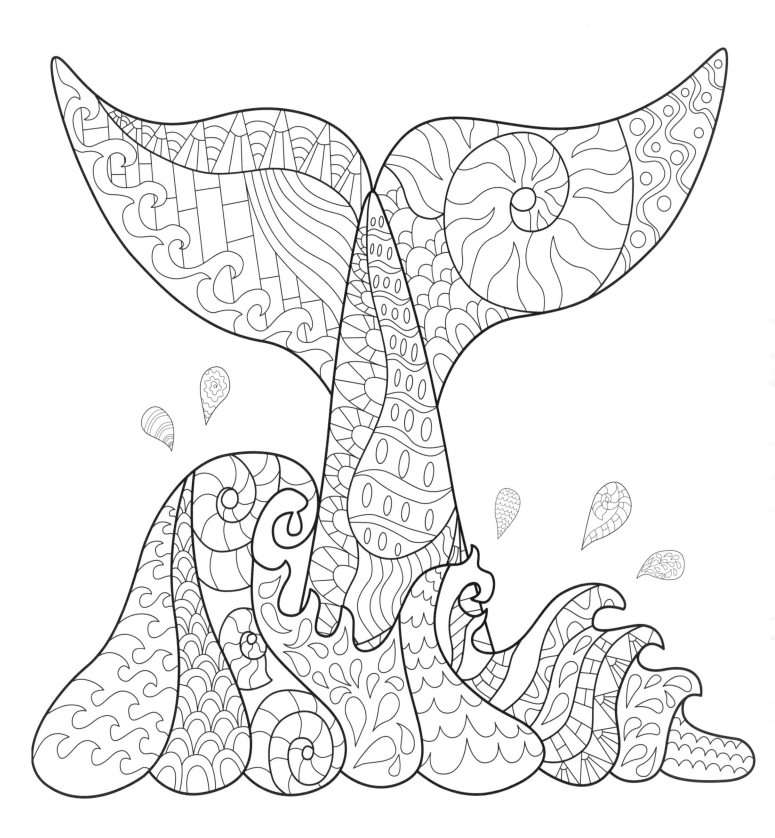

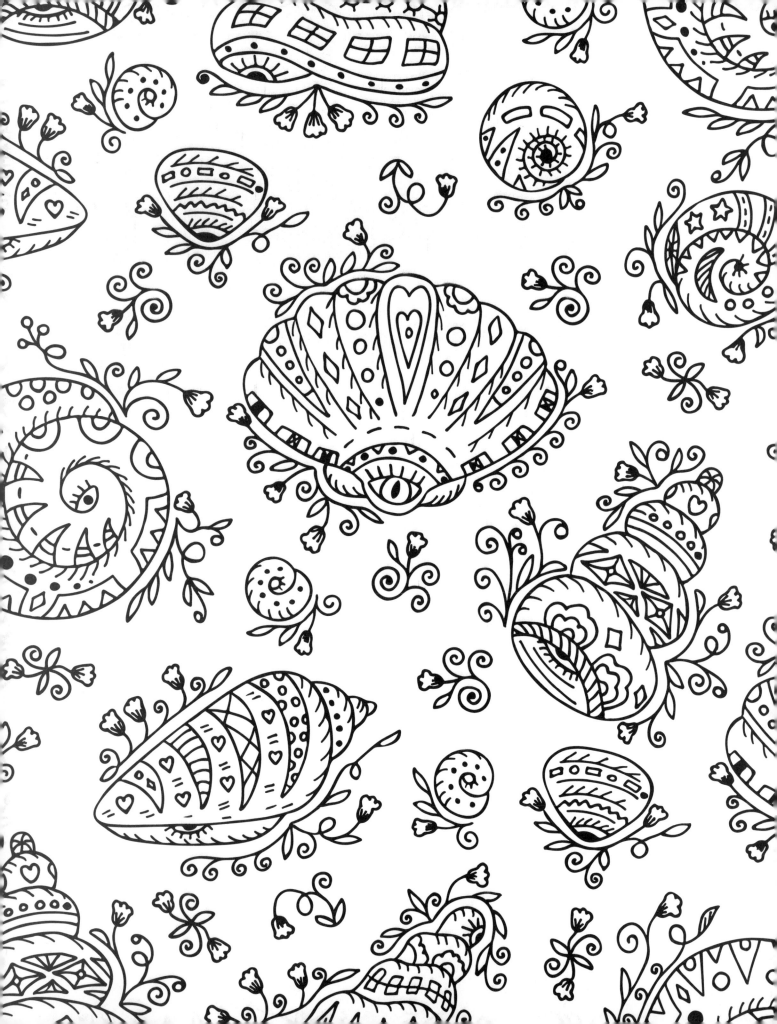

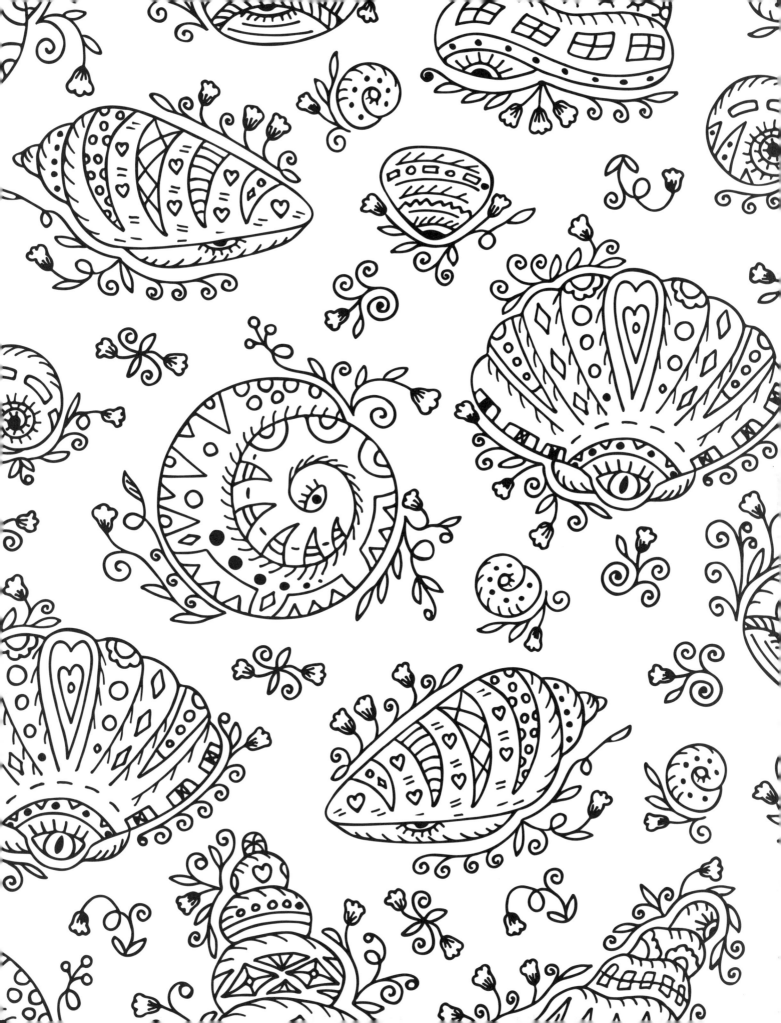

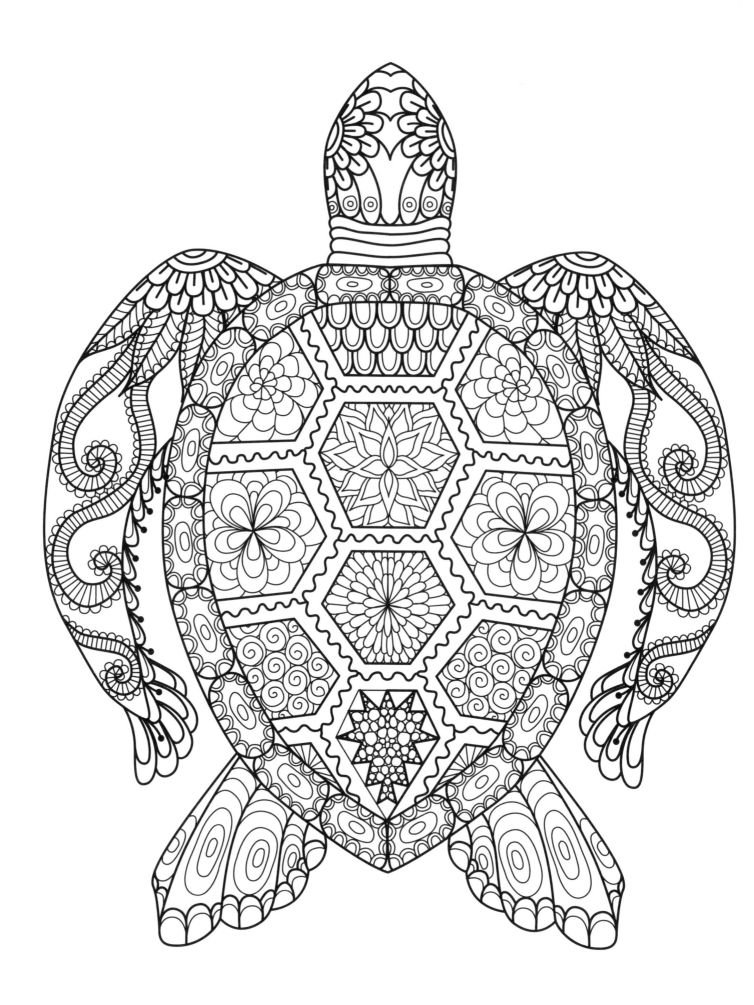

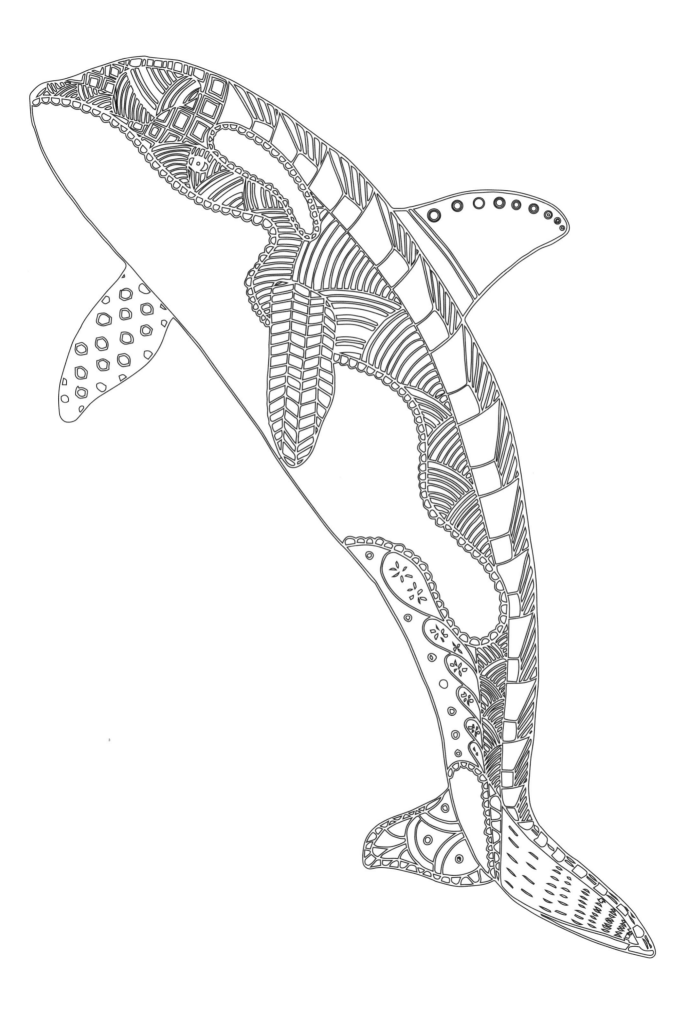

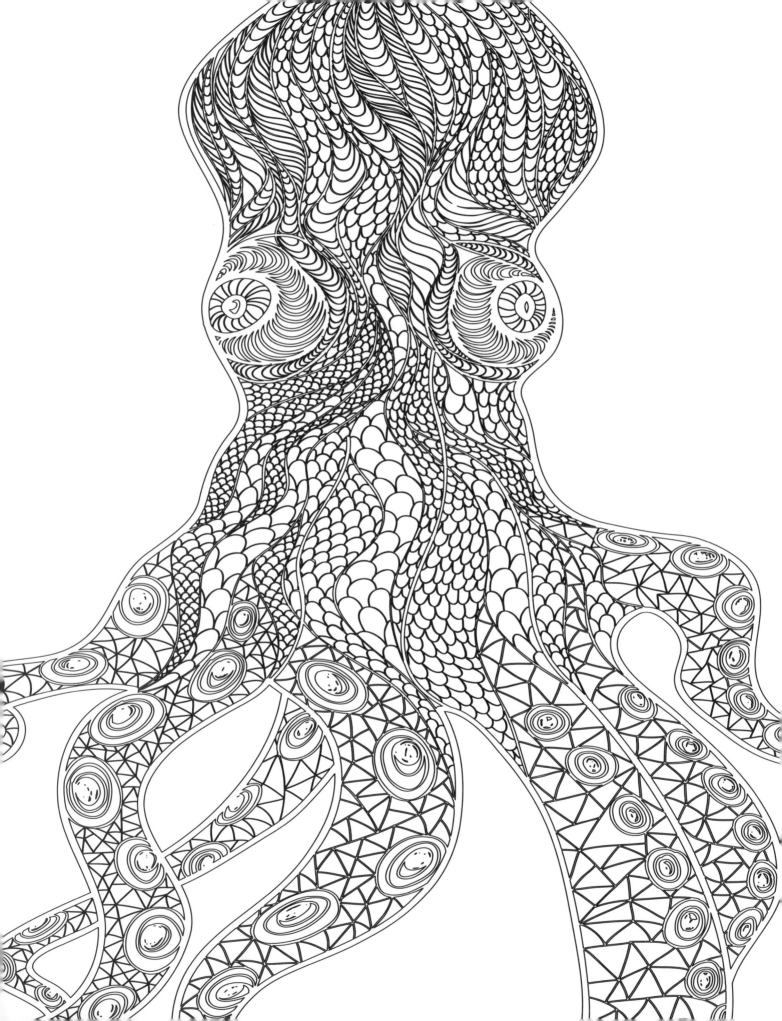

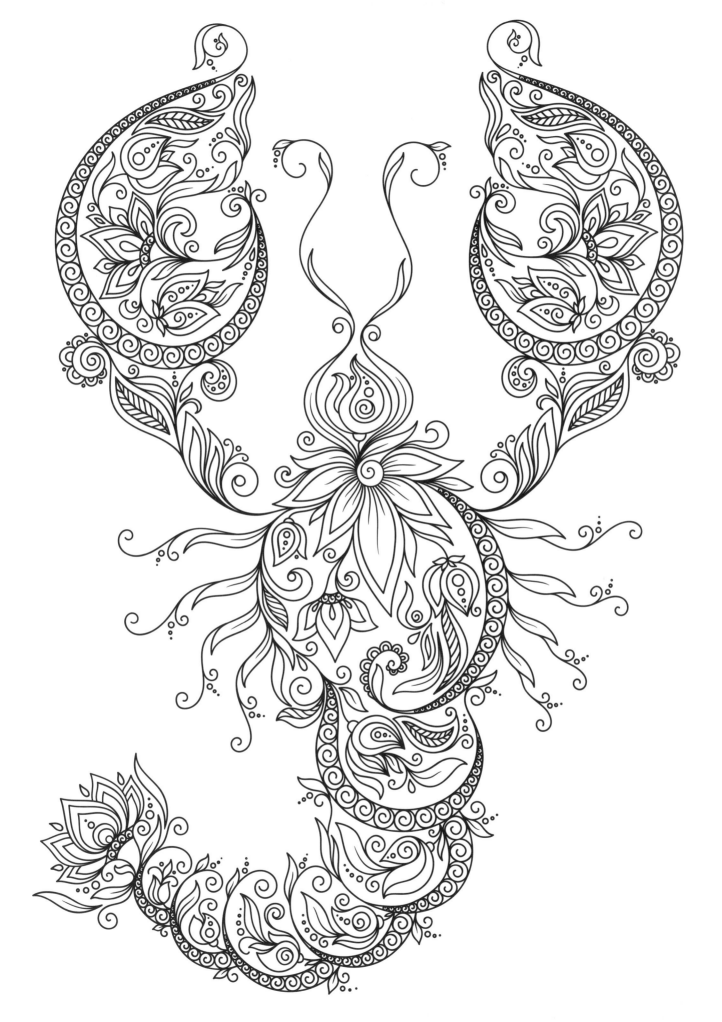

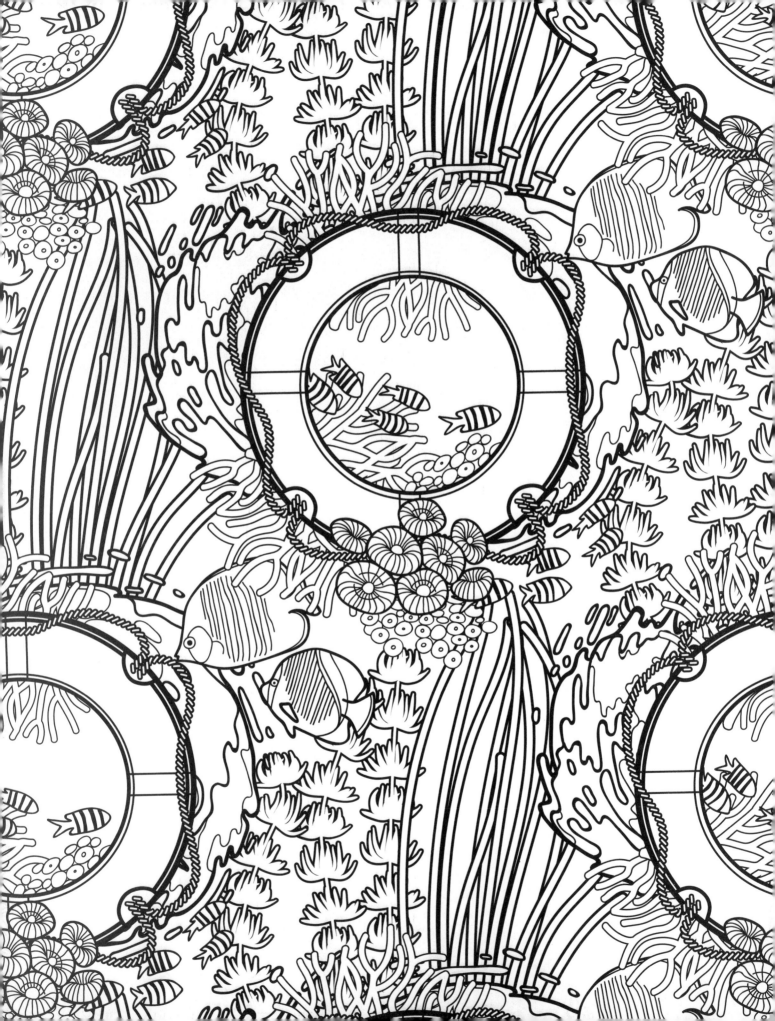

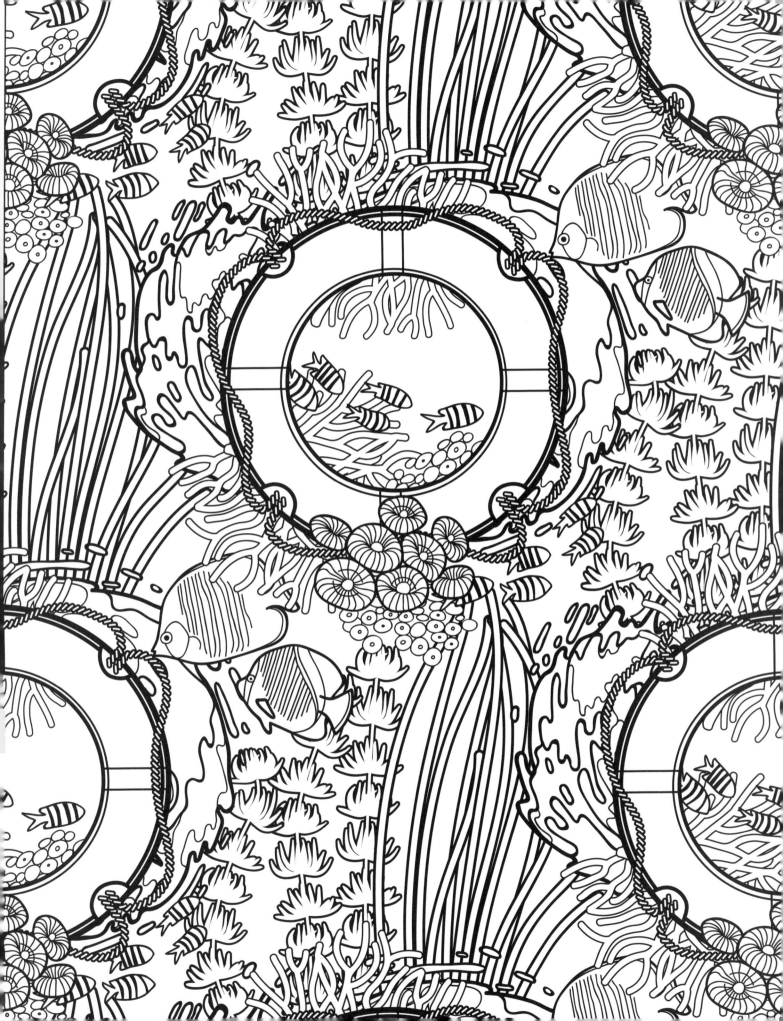

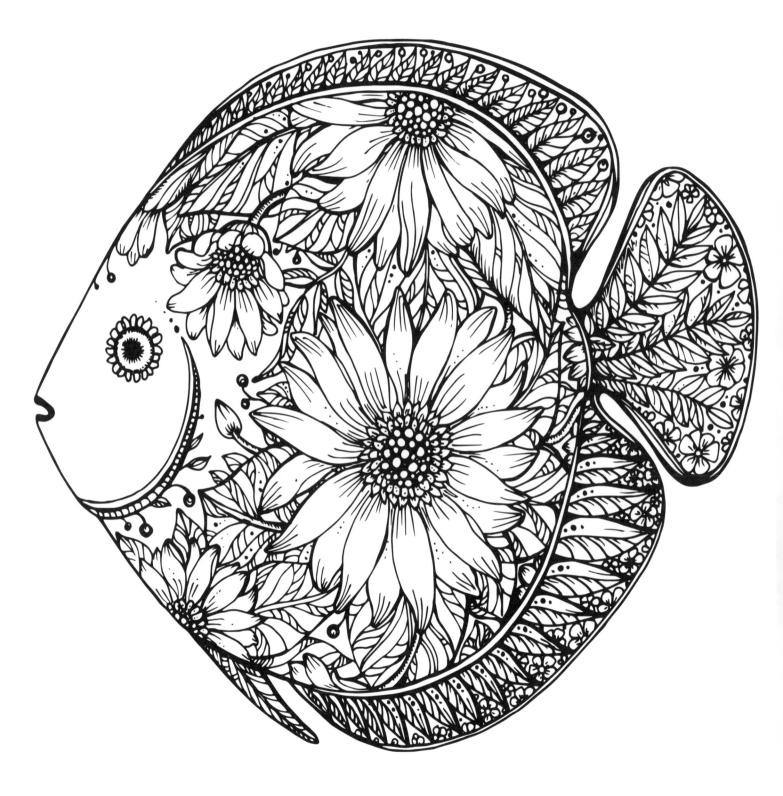

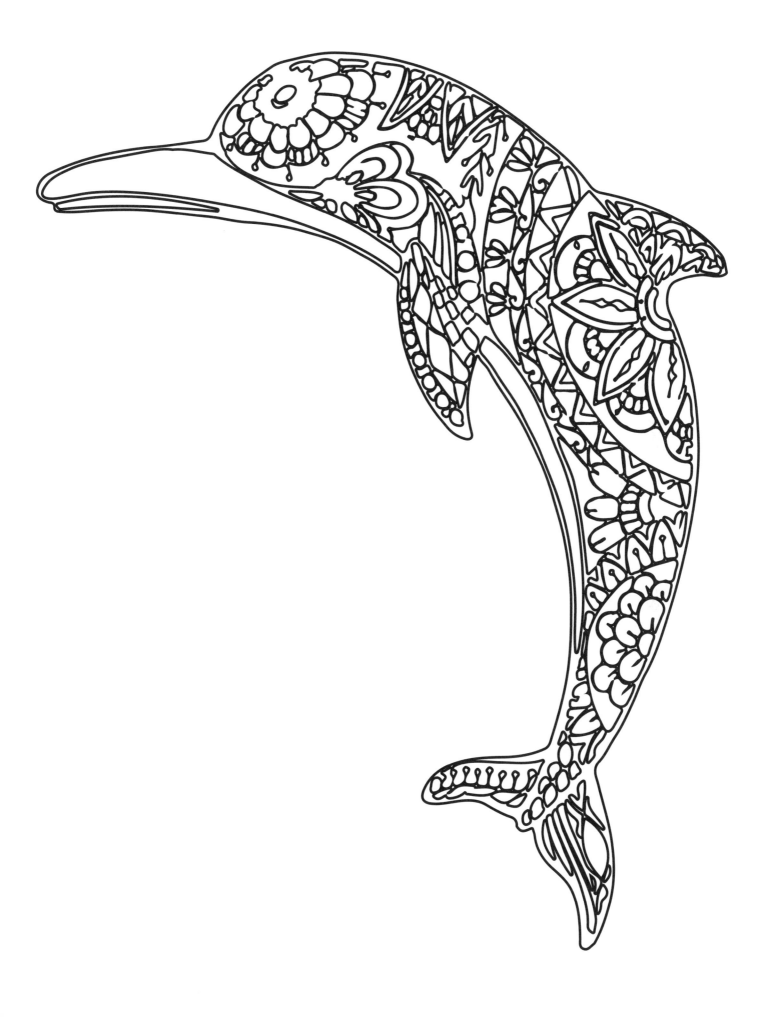

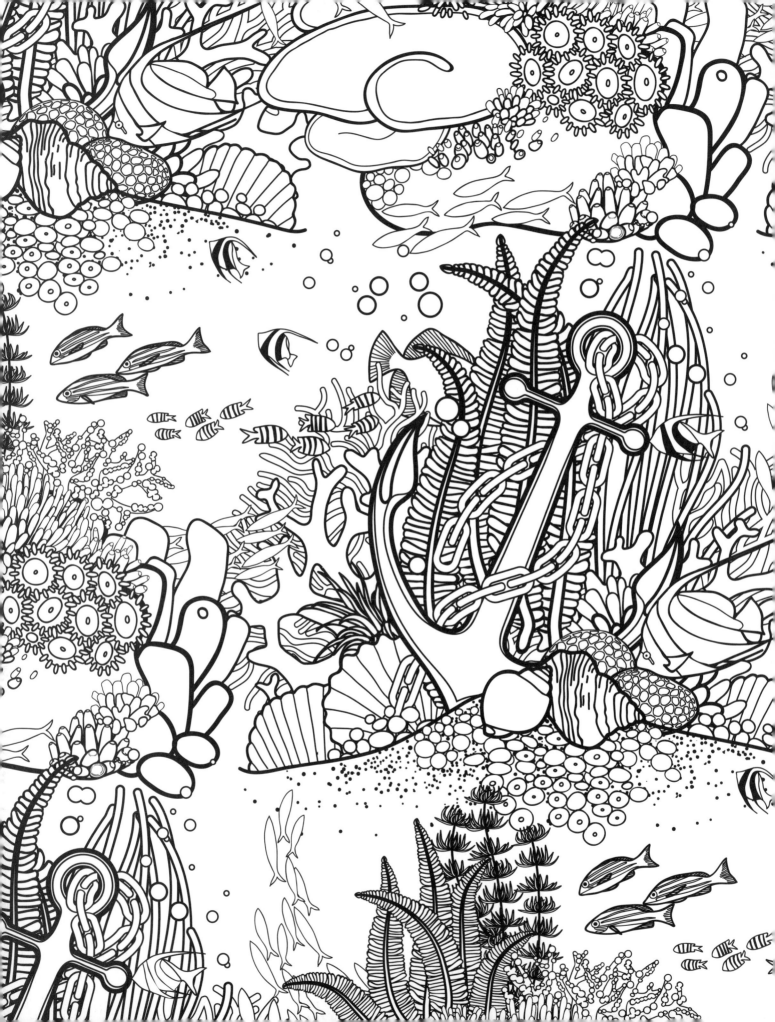

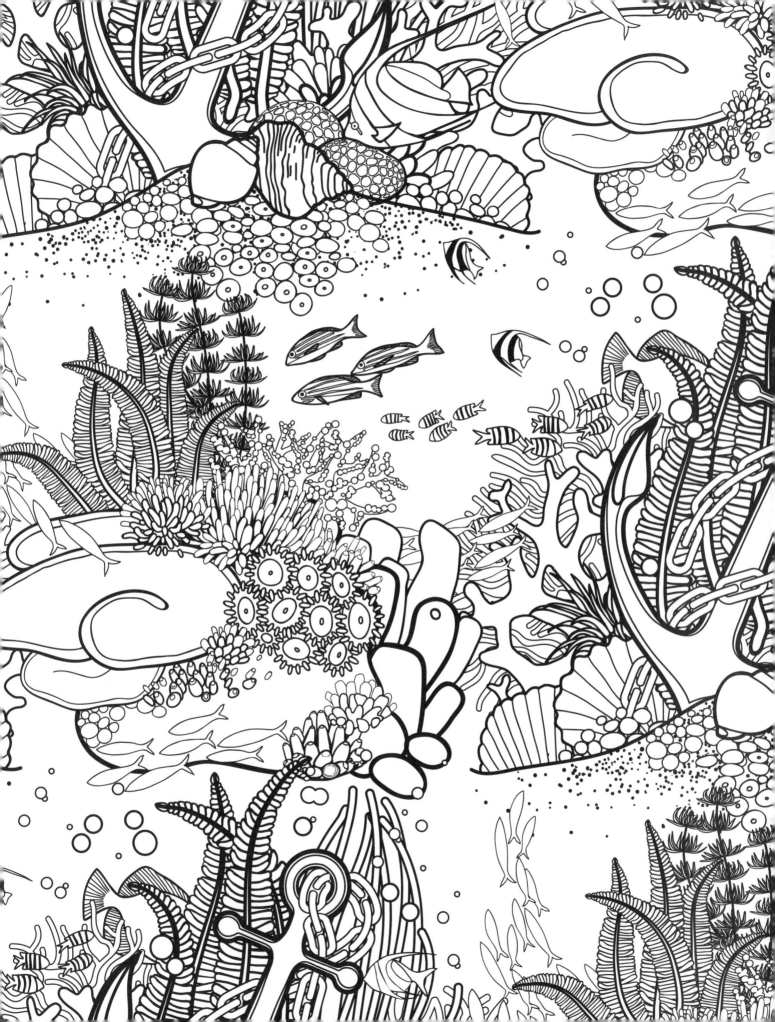

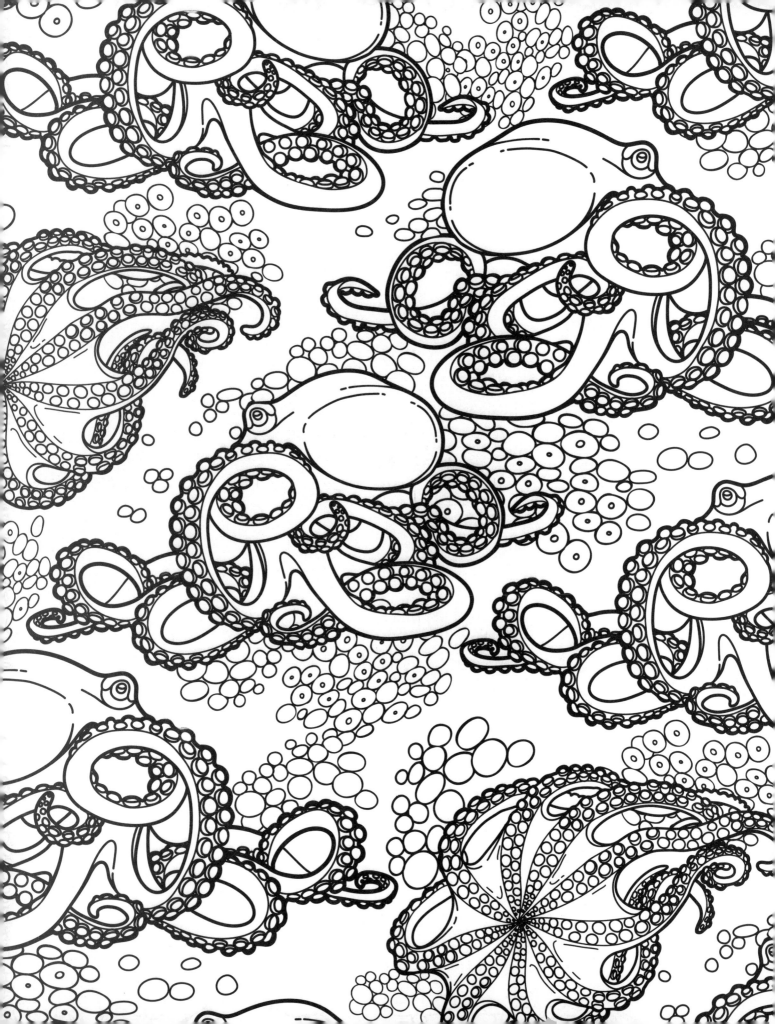

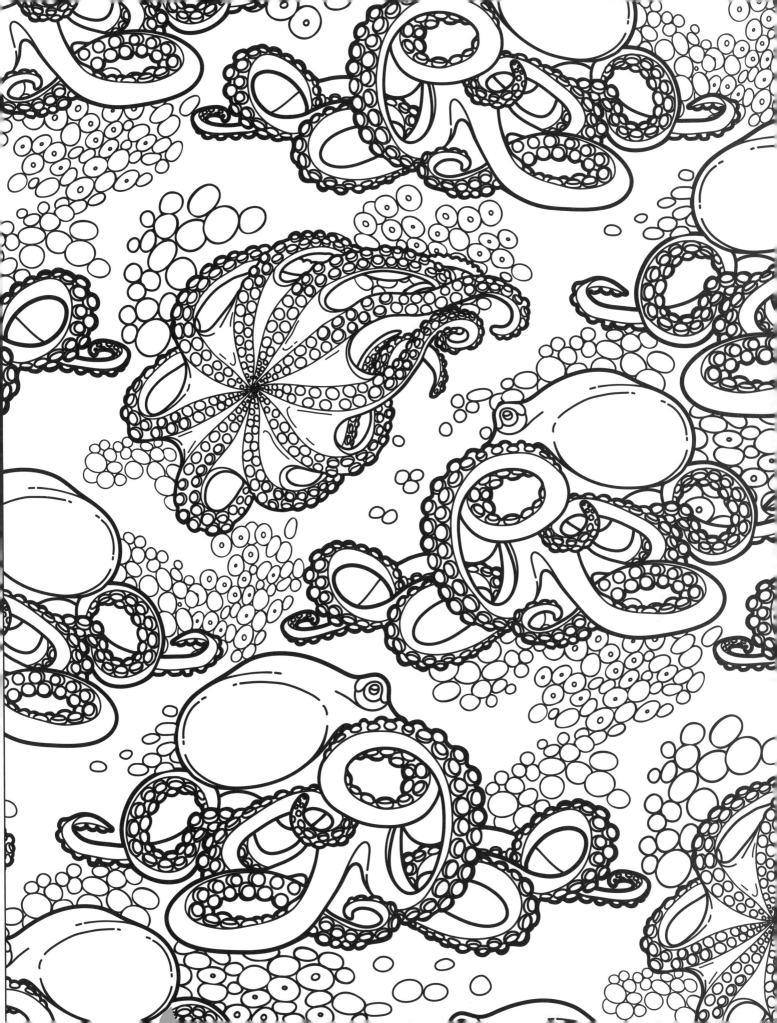

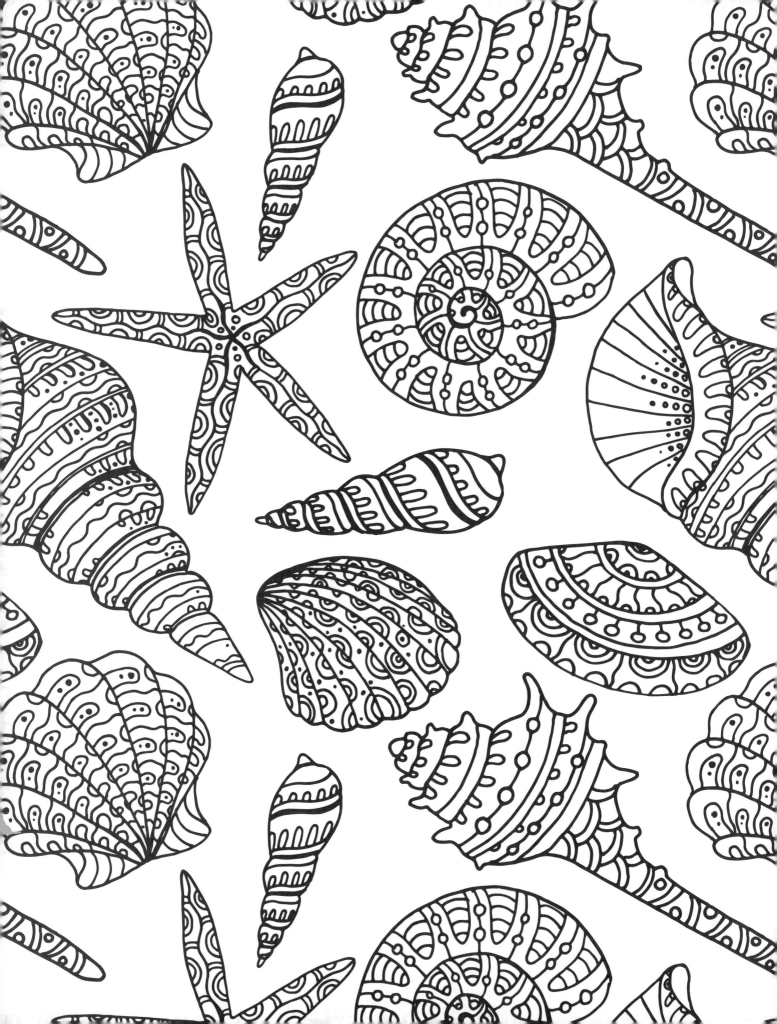

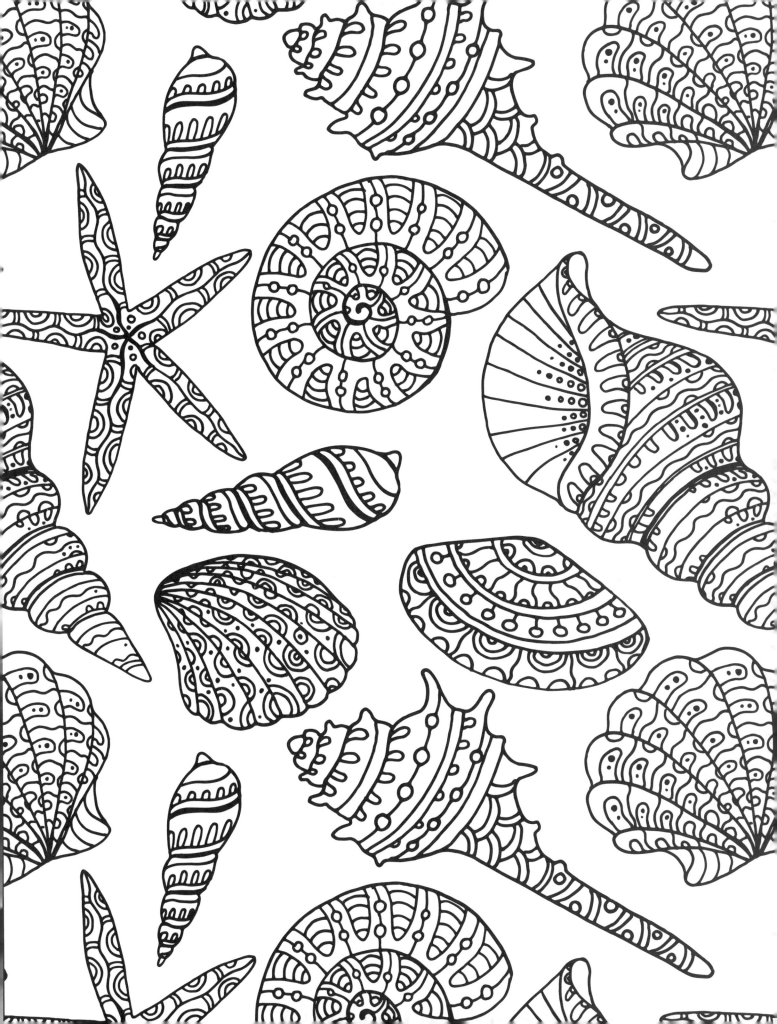

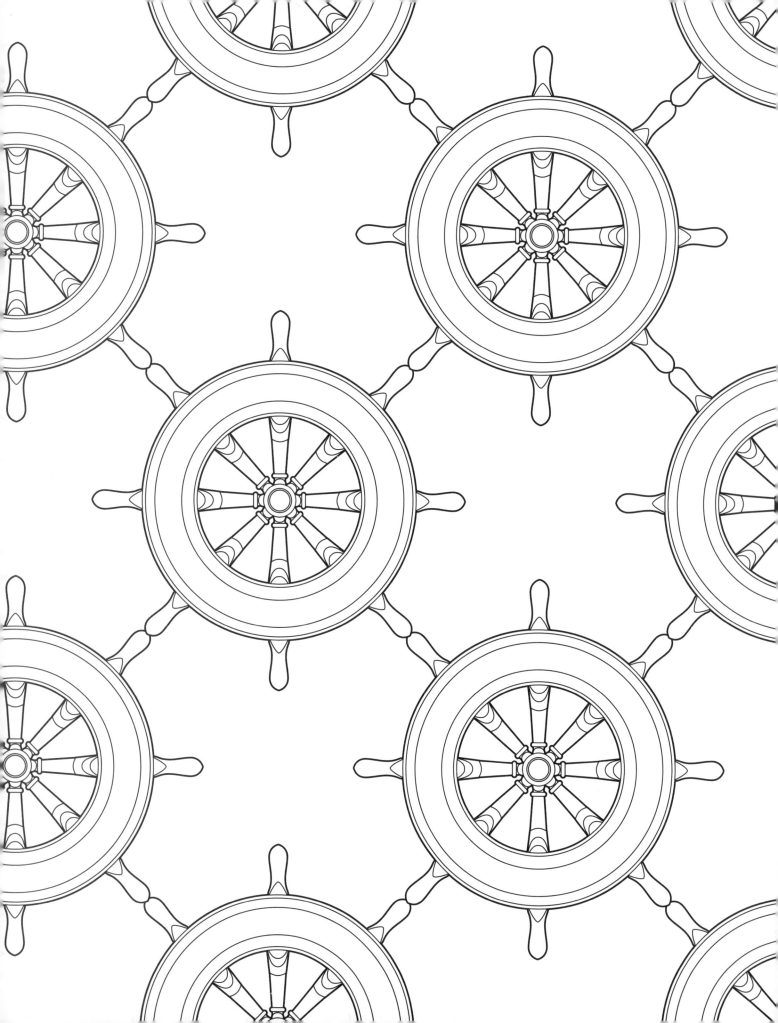

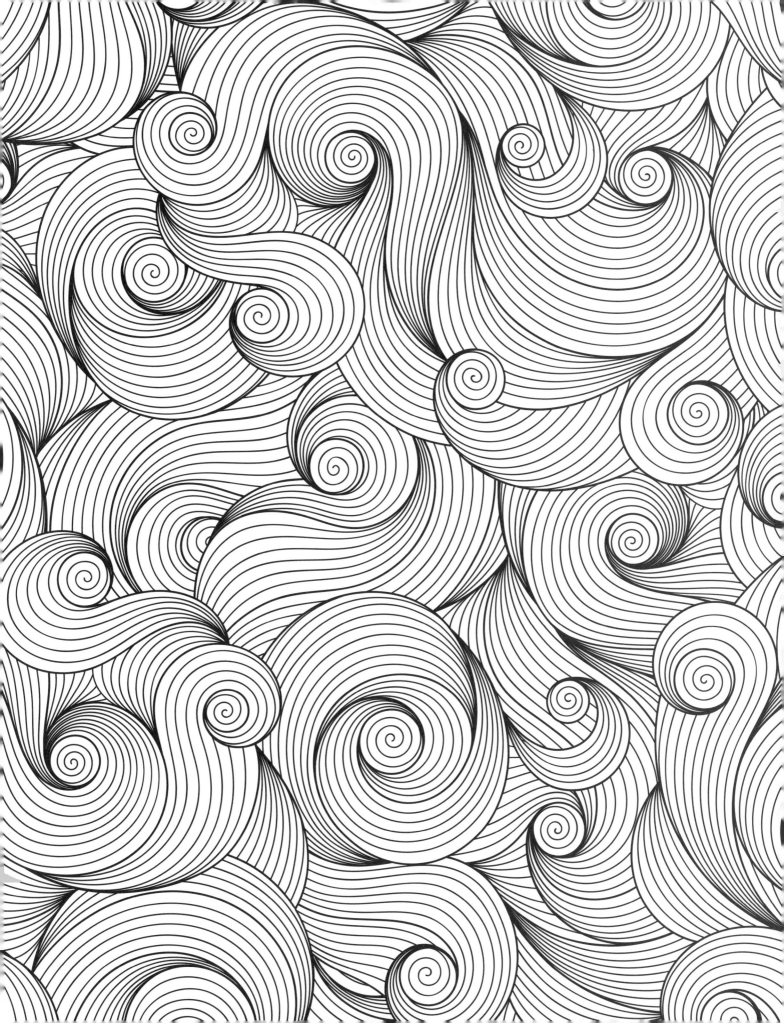

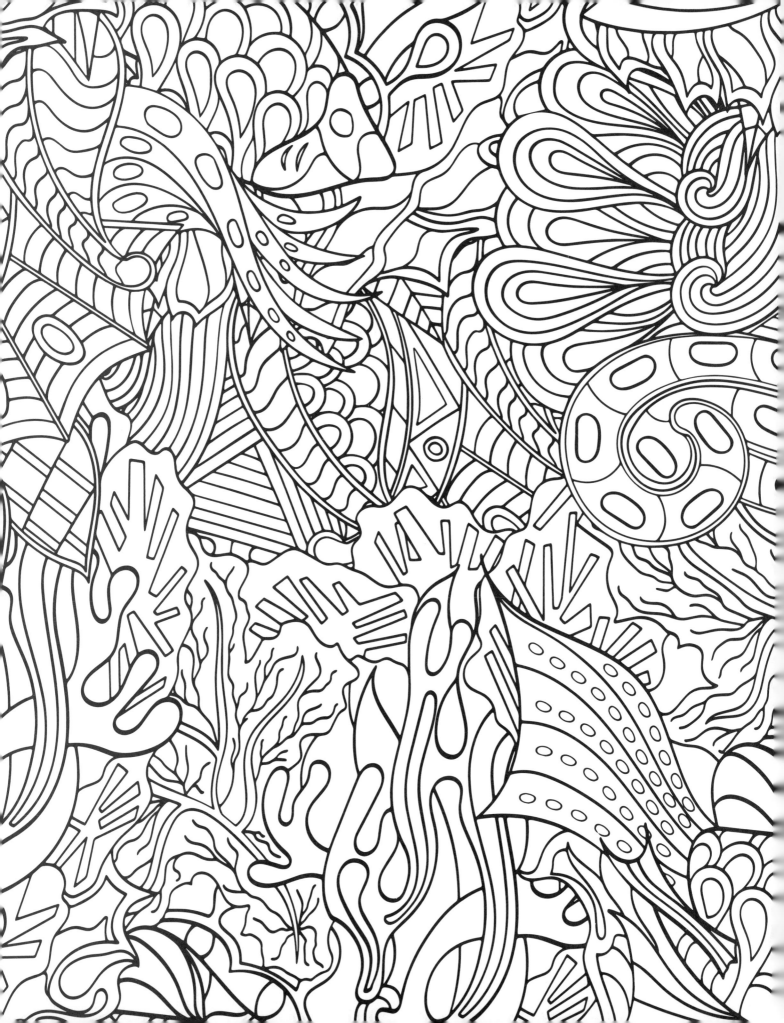

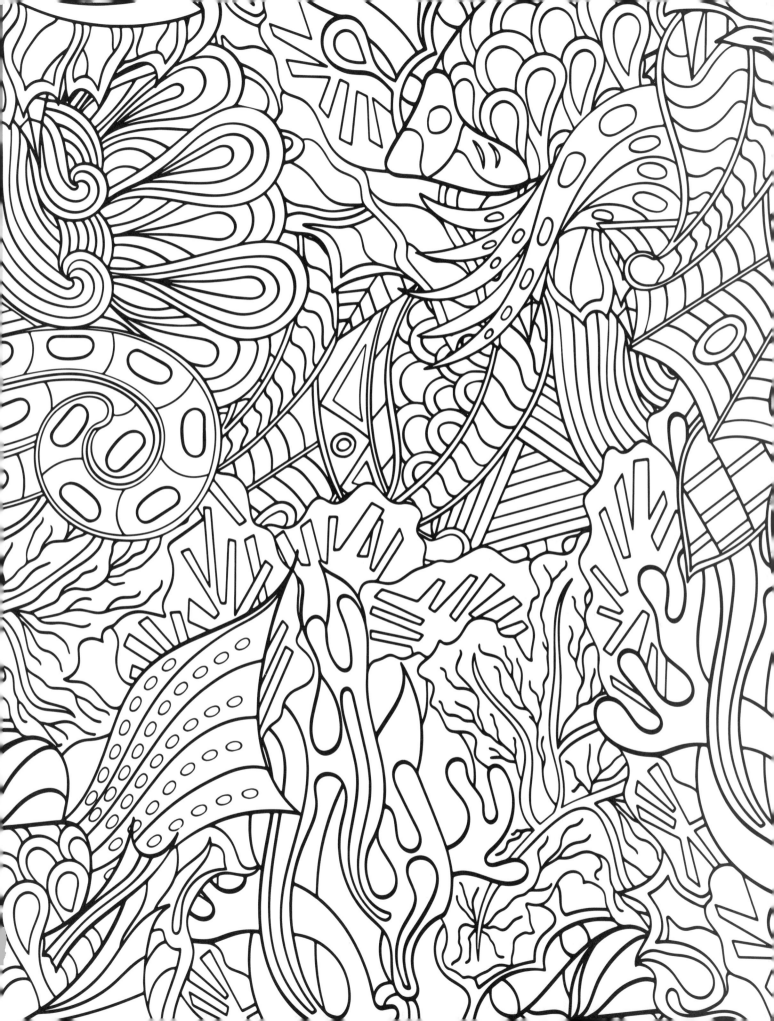

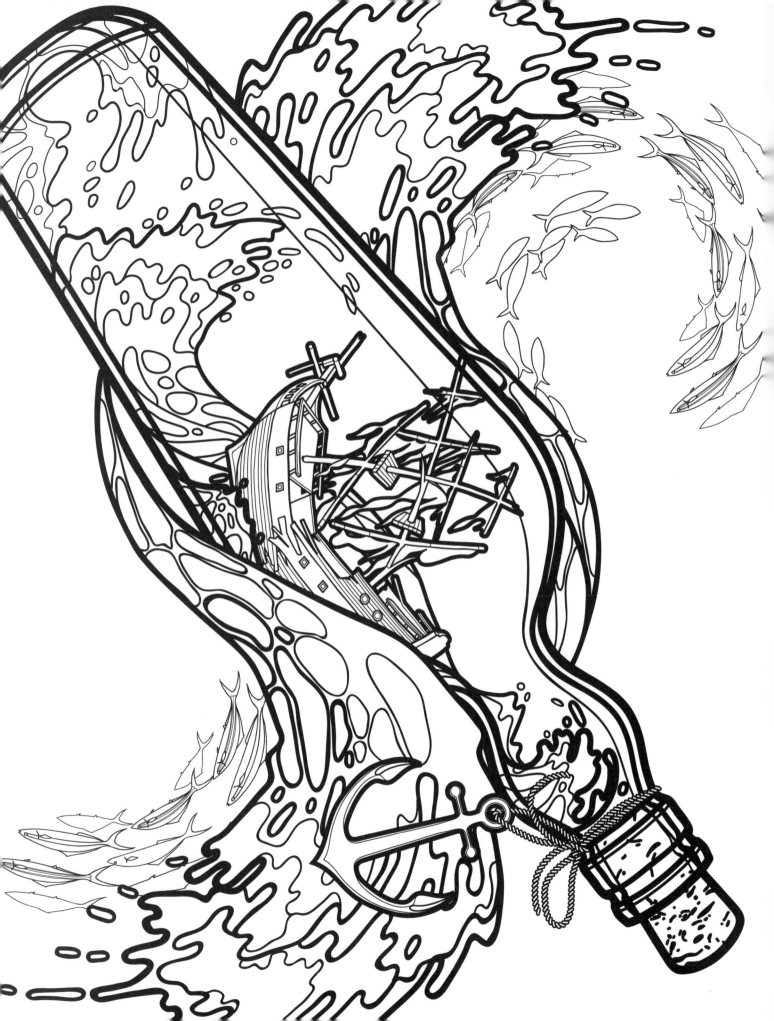

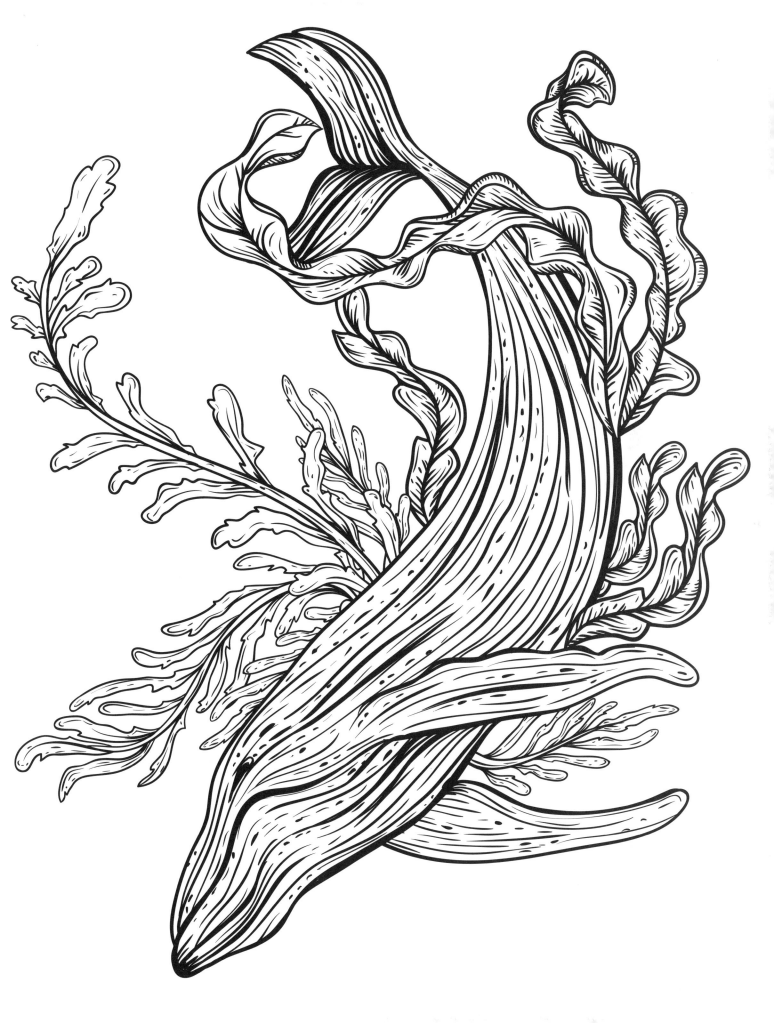

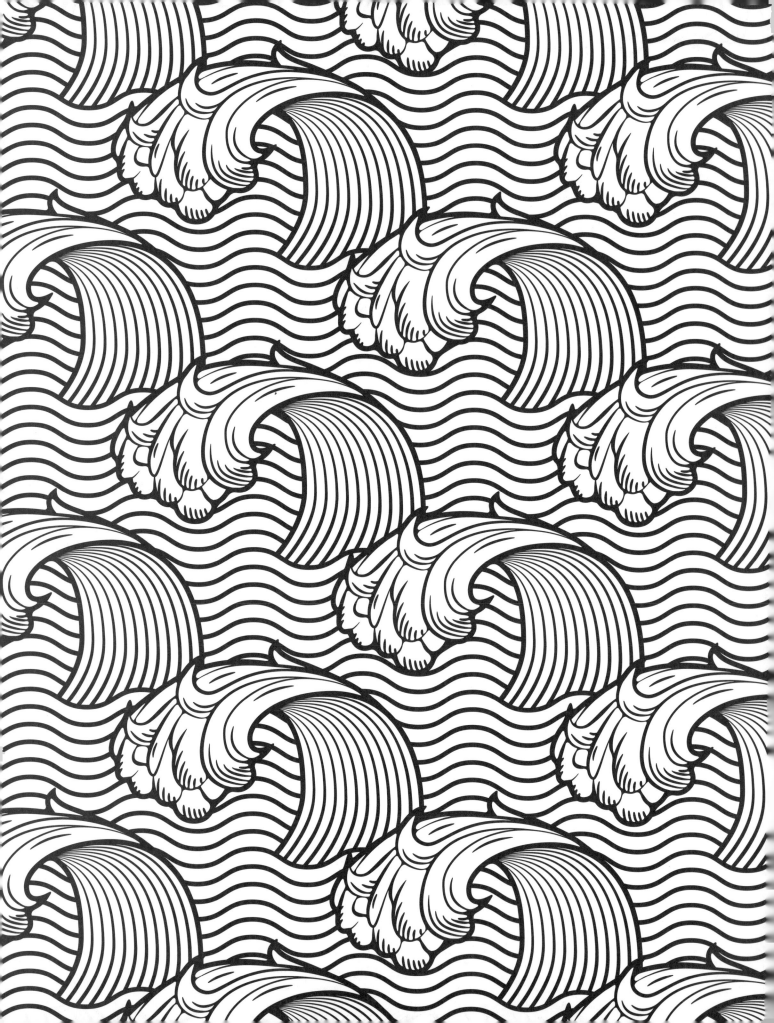

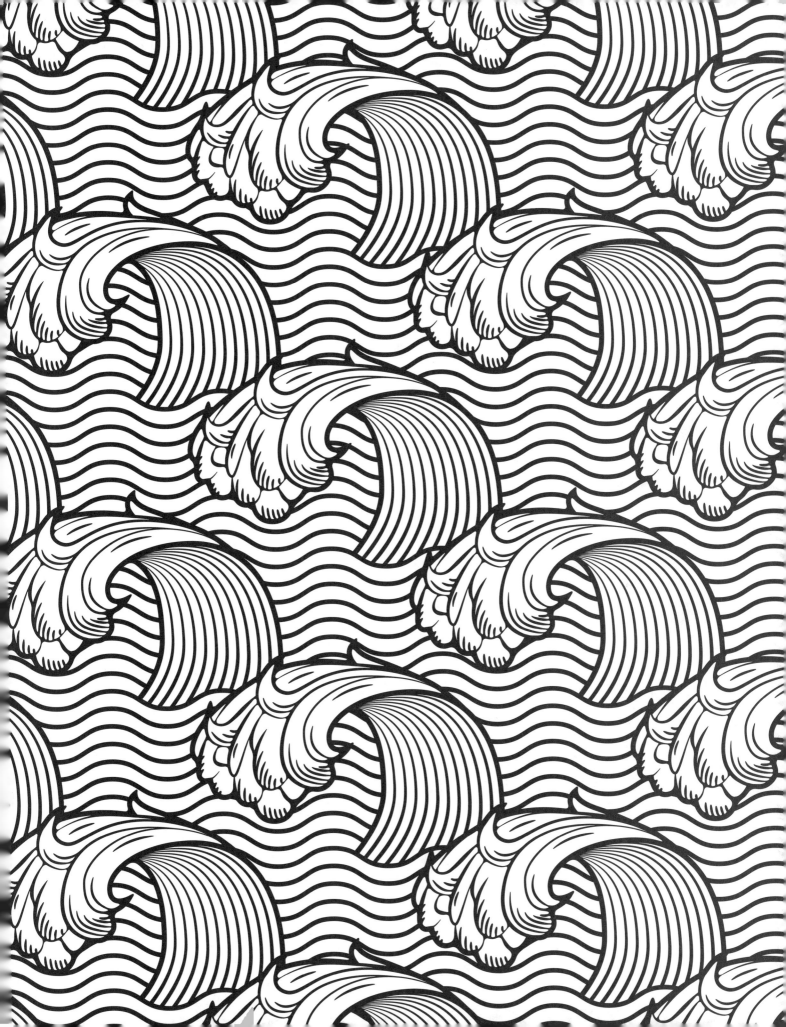

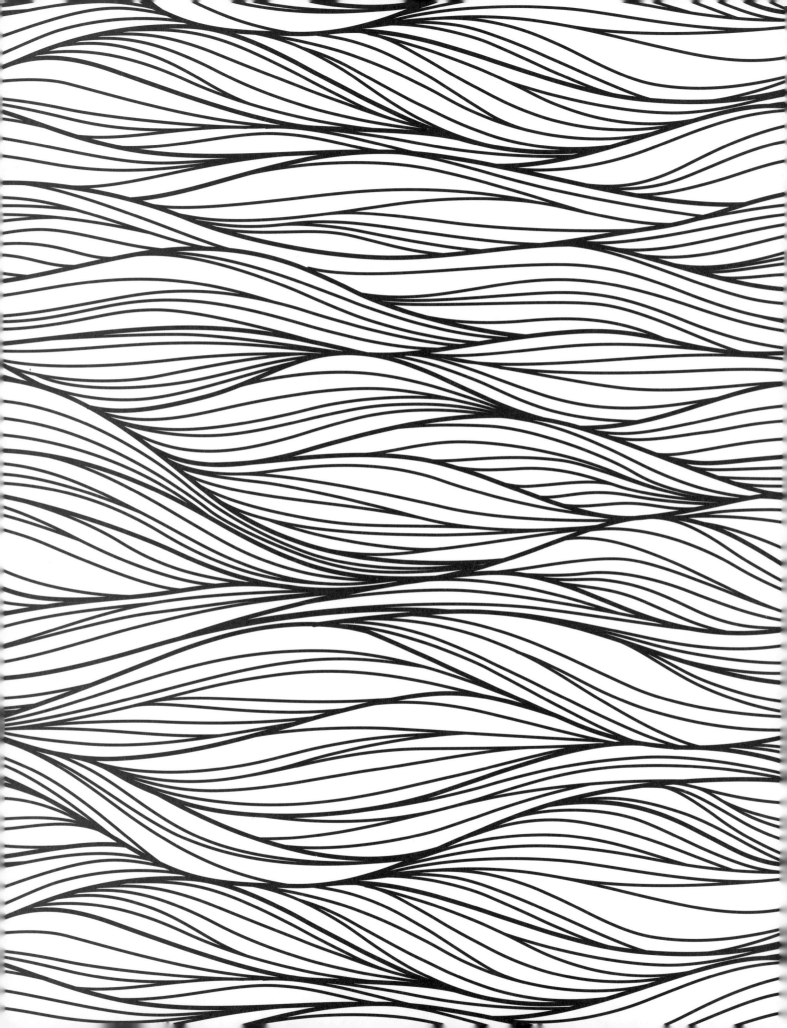

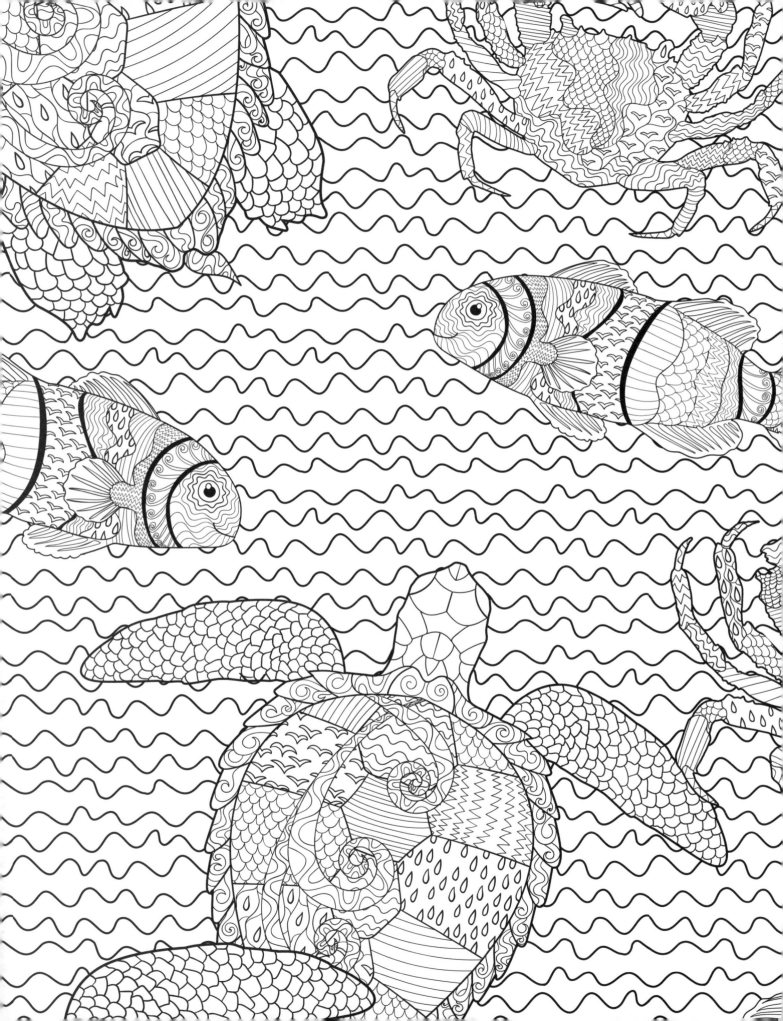

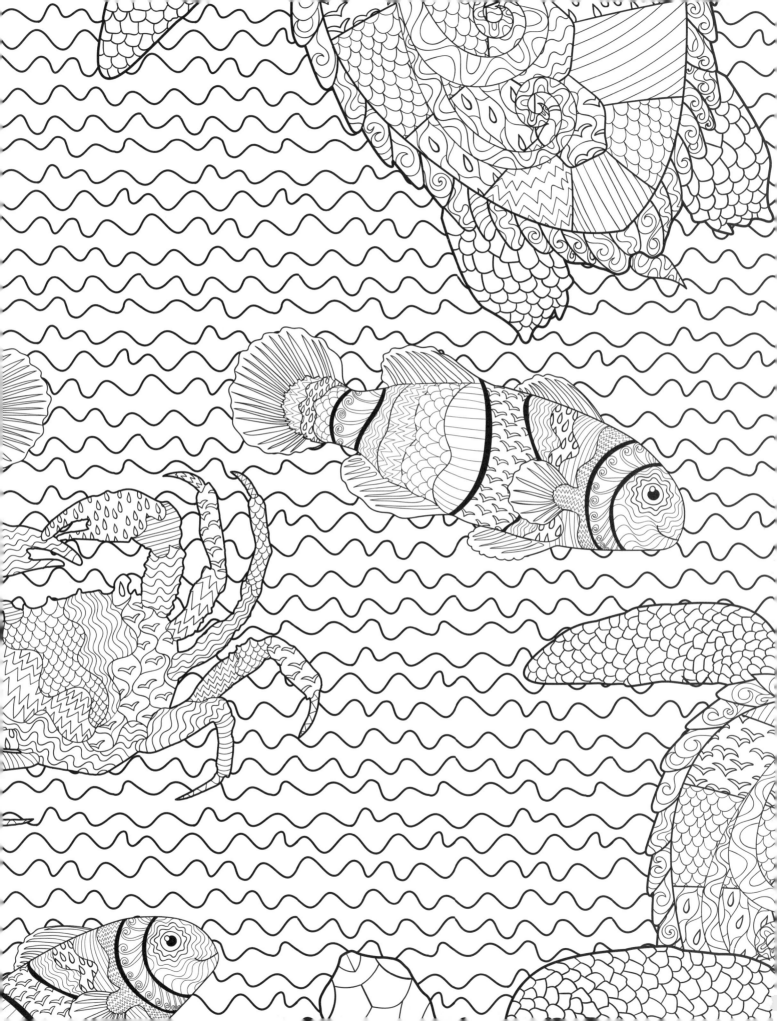

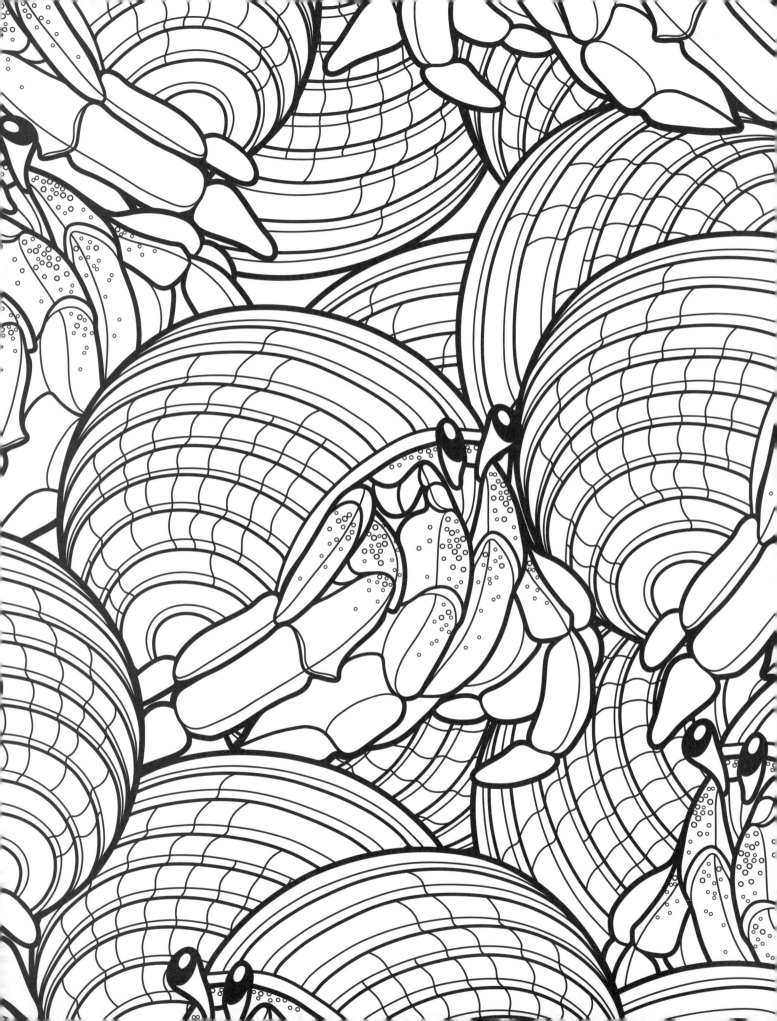

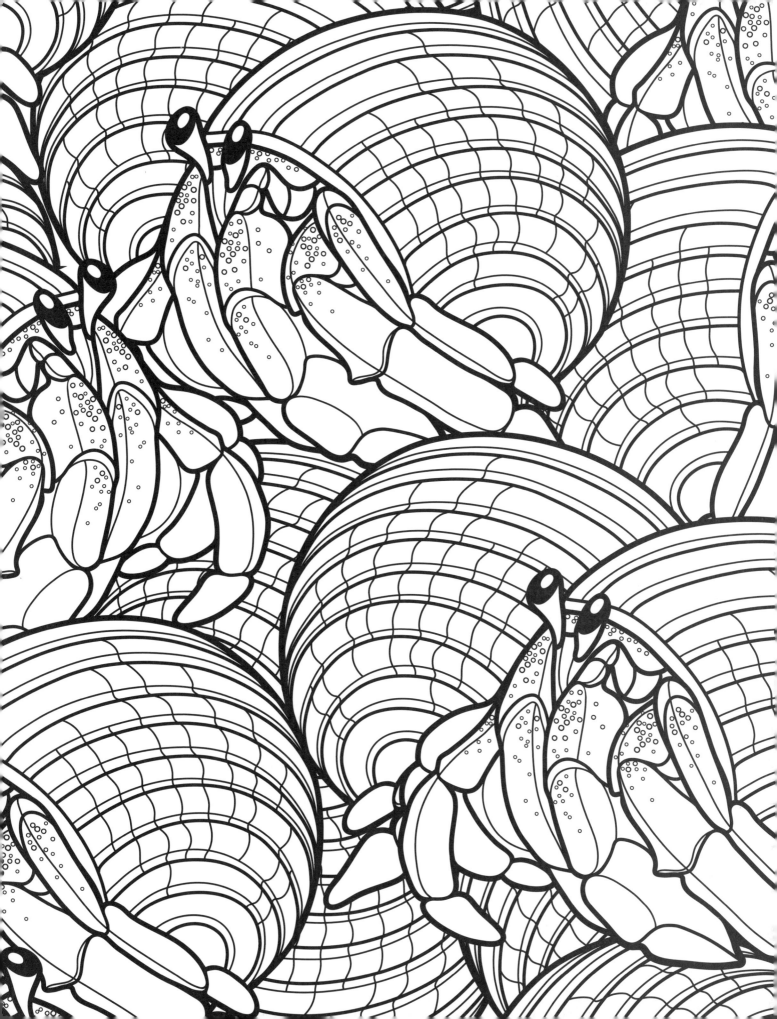

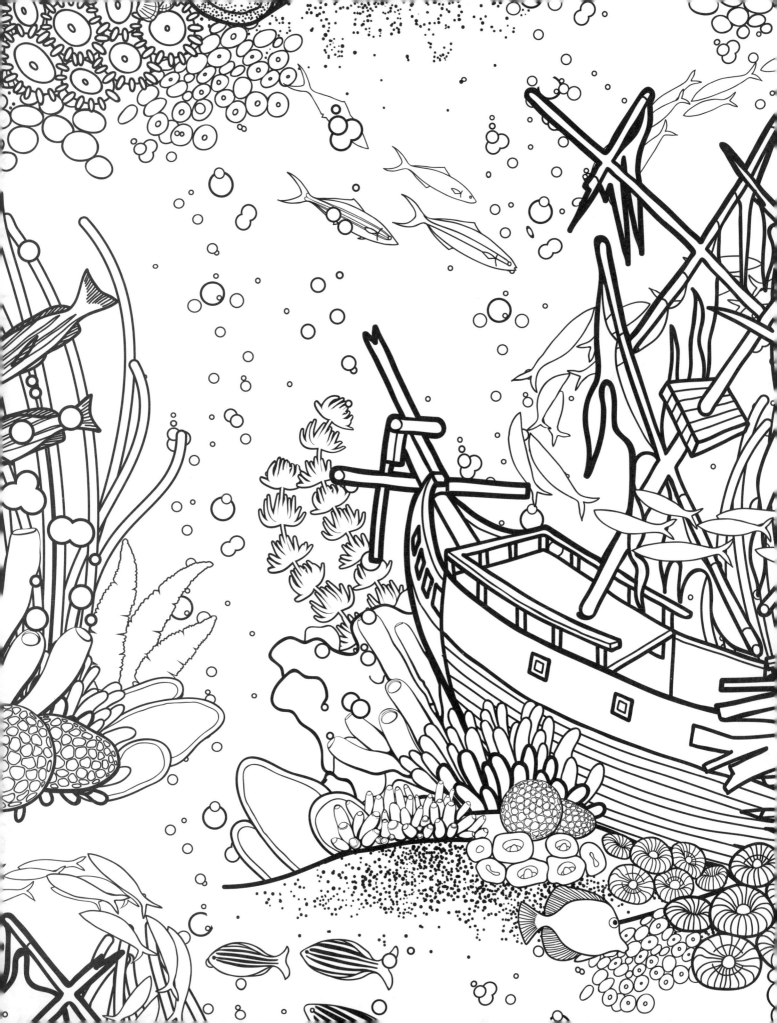

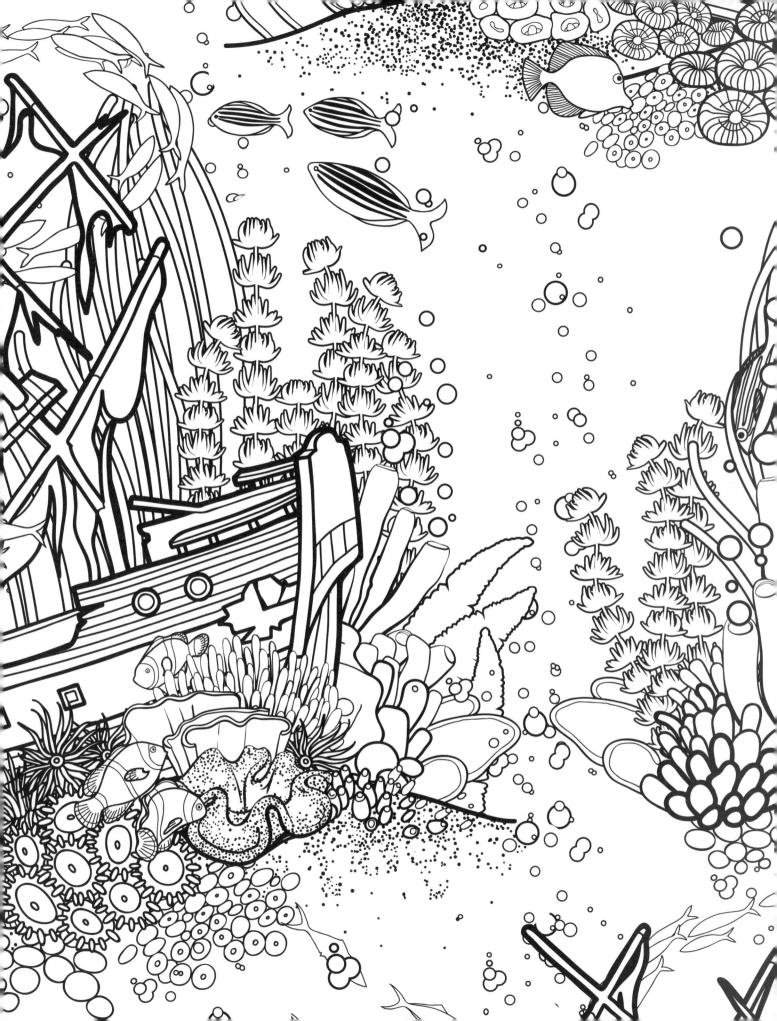

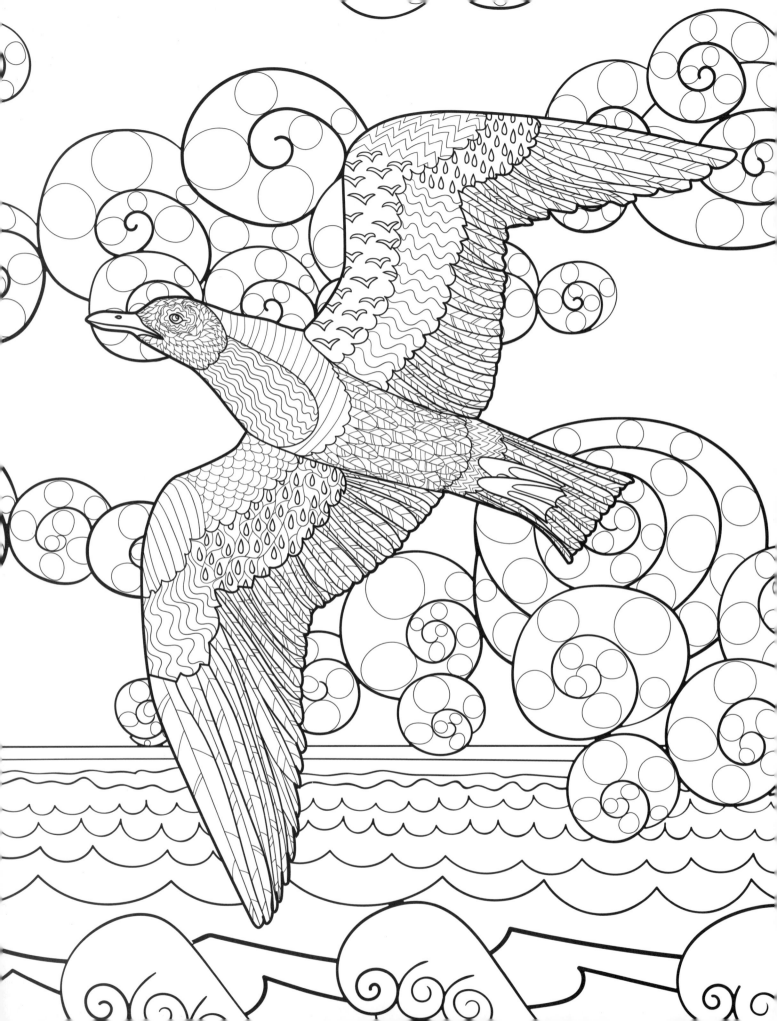